THE
PICTURE MAN

FROM THE COLLECTION OF BAY AREA
PHOTOGRAPHER E.F. JOSEPH
1927–1979

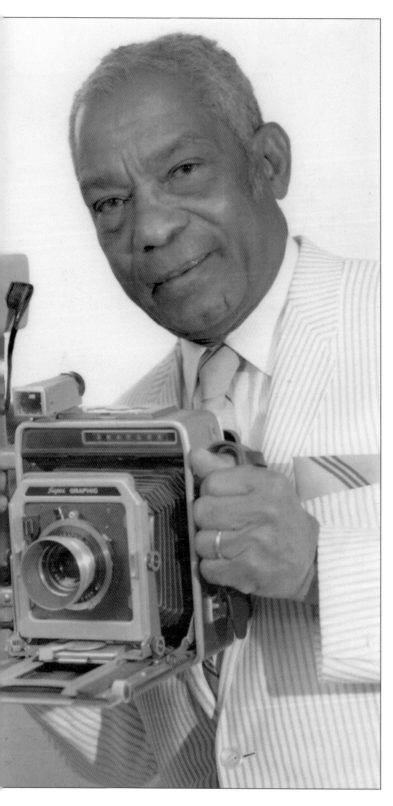

ON THE COVER:
E.F. Joseph is ready for work.

UPPER BACK COVER:
The Ink Spots (see page 26)

LOWER BACK COVER:
(from left to right)
The Katherine Dunham
Dancers (see page 18),
customers of Davis Furrier in
San Francisco (see page 65),
Bartenders Union Local 598
at the 53 Club (see page 113)

THE
PICTURE MAN

FROM THE COLLECTION OF BAY AREA PHOTOGRAPHER E.F. JOSEPH 1927–1979

CARETH REID & RUTH BECKFORD

ARCADIA
PUBLISHING

Published by Arcadia Publishing
Charleston, South Carolina

Printed in the United States of America

Library of Congress Control Number: 2016957802

For all general information, please contact Arcadia Publishing:
Telephone 843-853-2070
Fax 843-853-0044
E-mail sales@arcadiapublishing.com
For customer service and orders:
Toll-Free 1-888-313-2665

Visit us on the Internet at www.arcadiapublishing.com

To my mother Mary Alice Kimbrough-Bomar
my daughter Gail Adele Reid
my son Frederick Willis Reid III
my husband Frederick Willis Reid Jr.

—Careth Reid

To my mother Cora Gertrude Beckford
and her sisters "The Fowler Girls
my cousin Bobbi Fisher
my niece Linda Speed
my extended family Ron and Cle Thompson

—Ruth Beckford

CONTENTS

Acknowledgments 6

Introduction 7

1. The Man Behind the Lens 9

2. The Arts 15

3. Business 29

4. Churches 39

5. Civil Rights 45

6. Clubs 51

7. Family 57

8. Glamour Girls 63

9. Greek Life 67

10. Military 73

11. Politics 85

12. Railroads 97

13. Sports 103

14. Unions 113

15. Weddings 119

Index 124–125

About the Authors 126–127

ACKNOWLEDGMENTS

Special thanks to my children, Fred Reid and Gail Reid, for making my day-to-day life less stressful. I would also like to thank the following: Dawn Foster, computer formatting and editing assistant; Hank Chan, photograph reproduction from the negatives; Gene Hazzard, head shot photographer; genealogist Electra Price, early researcher; Betty Reid-Soskin, early researcher and the oldest park ranger in the US at the Rosie the Riveter Park in Richmond; Tina Walters, early researcher; Aloysia Fouche, early researcher; Mary Savoie-Stephens, early researcher; and Bob Clinton, technical support.

—Careth Reid

Thank you to all my friends who were happy to see me busy working on another project at 90 years old. They said it gave them inspiration and motivation to keep going regardless of age.

—Ruth Beckford

INTRODUCTION

E.F. Joseph began his work documenting black families, personalities, events, and so on in the Bay Area communities throughout California in 1927 and did not stop until his death in 1979. He submitted much of this documentation to the *Pittsburgh Courier* and the *Chicago Defender* newspapers in which they were printed. Before the 1950s, black news was not printed in the local white newspapers; consequently, black families in California and in the South subscribed to the *Courier* and the *Defender* for news in their communities.

In 1980, author Careth "Diddy" Reid purchased, for $2,000, Joseph's entire collection of negatives, personal papers (including his correspondence with relatives in St. Lucia), medical files, business papers, invitations, and government base authorizations from his second wife, Lucy. His first wife, Alyce, had predeceased him on August 11, 1963, due to liver failure.

His widow, Lucy, was closing her husband's estate after his death of anemia and chronic renal failure on September 27, 1979. She was offered $2,000 for countless negatives by a white buyer who planned to recycle the silver nitrate on the negatives, thereby destroying the captured black history. Diddy asked Lucy if she would consider selling the entire collection to her for the same price. Lucy agreed as long as Diddy would take all of his records and documents, not just the negatives, and brought her a check before the other buyer.

Diddy delivered the check the following day and brought a truck to move all the materials. She stored the collection in the basement of her apartment building in San Francisco until retiring from her position as director of the Whitney Young Child Development Center on her 70th birthday in 2001. Two years later, Diddy traveled to St. Lucia, where Joseph was born and raised, hoping to find remnants of his family. Unfortunately, there must have been a large Joseph plantation on the island because almost everyone had the same last name. However, she was able to locate his sister Catherine, who was in her late 90s and still living at home. Catherine allowed Diddy to photograph her and her home, as well as all the old family pictures, which included parents, siblings, grandparents, and great-grandparents. She also let her record their interview.

As the beneficiaries of E.F. Joseph's collection, Careth Reid and coauthor Ruth Beckford are delighted to share these iconic images, which preserve the history of African Americans in the Greater San Francisco Bay Area. The first chapter of this book takes a look at the man behind the lens, and all subsequent chapters feature his photography, which has been organized by genre. So relax, read on, and enjoy the journey.

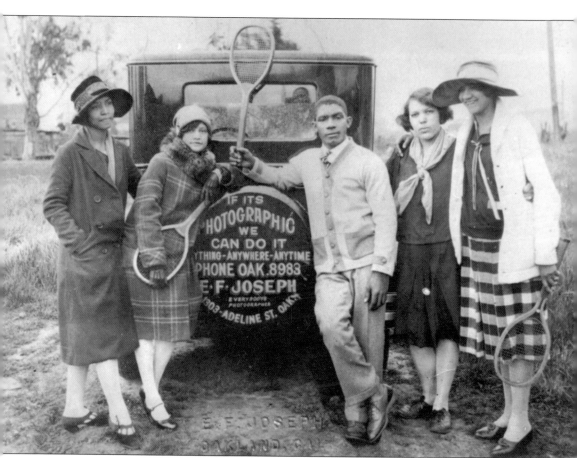

This photograph shows the wording on the back of E.F. Joseph's car: "If it's photographic we can do it: anything–anywhere–anytime."

One

THE MAN
BEHIND THE LENS

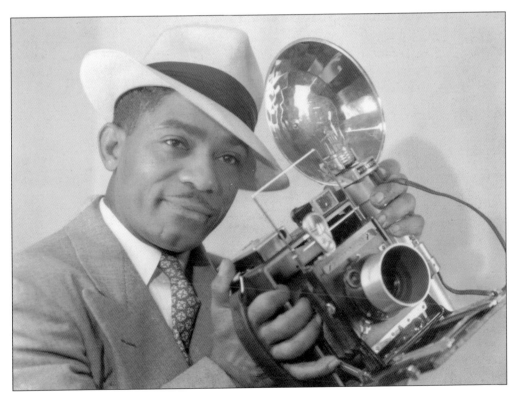

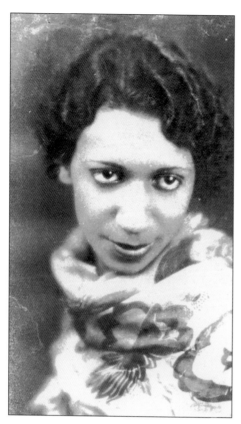

Alyce E. Joseph was not only his wife but also his partner, assisting him on photography shoots.

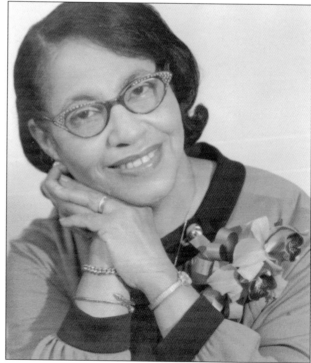

Lucy Lartigue Joseph, his second wife, was born in 1901 in St. Lucia, where she also went to school to become a nurse. Lucy later moved to New York City and remained there until she married Joseph.

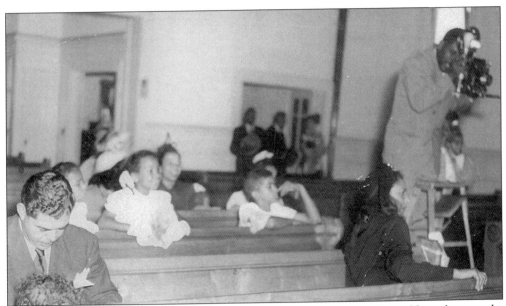

E.F. Joseph is seen here in action in 1949. He balances on a ladder to take wedding photographs at the Taylor Memorial Church in Oakland. His wife, Alyce, is seated beside him, tossing up fresh lightbulbs and catching the spent ones.

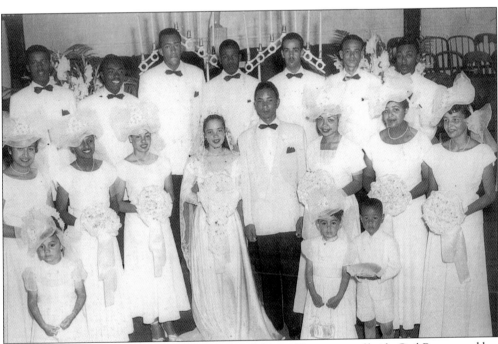

This is the photograph E.F. Joseph was taking of the wedding party of bride Gail Bomar and her new husband, Robert Sanders.

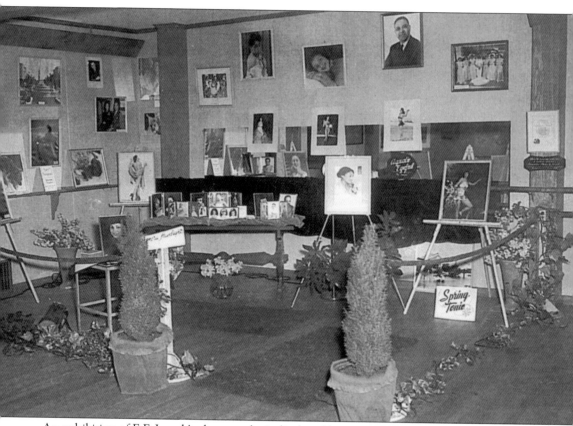

An exhibition of E.F. Joseph's photographs is displayed here.

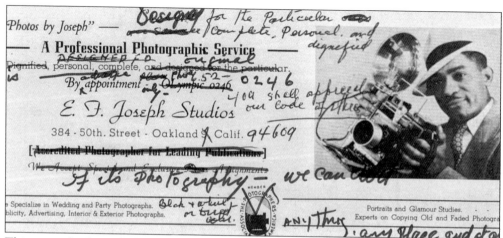

This is an edited proof of E.F. Joseph's business card.

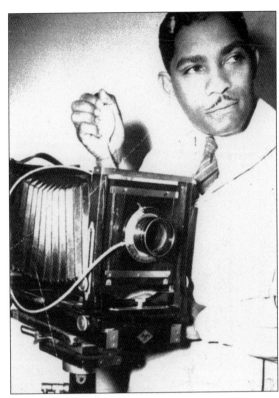

E.F. Joseph is pictured here with his camera, and his workroom is seen below.

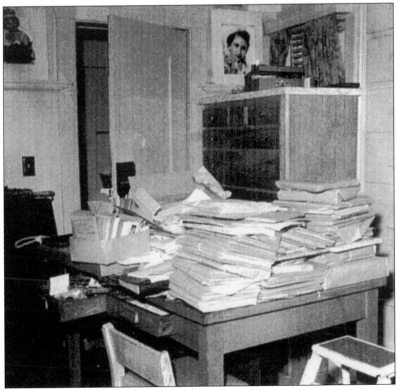

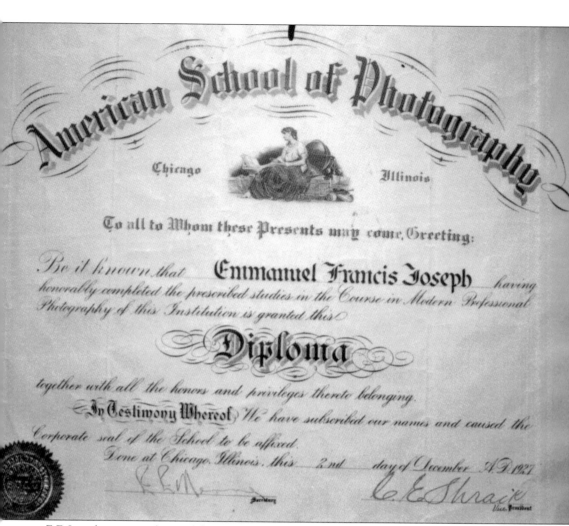

American School of Photography

Chicago — Illinois

To all to Whom these Presents may come, Greeting:

Be it known that **Emmanuel Francis Joseph** having honorably completed the prescribed studies in the Course in Modern Professional Photography of this Institution is granted this

Diploma

together with all the honors and privileges thereto belonging.

In Testimony Whereof We have subscribed our names and caused the Corporate seal of the School to be affixed.

Done at Chicago, Illinois, this 2nd day of December A.D. 1927

Secretary

C.E. Shraik
Vice-President

E.F. Joseph was a graduate of the American School of Photograph in Chicago, Illinois.

Two

The Arts

Lena Horne was born on June 30, 1917. She was the great-granddaughter of a freed slave. At age 16, she joined the chorus line at New York's famous Cotton Club. She toured with the Noble Sissle Orchestra. She was the first black performer hired to sing with a major white band, the Charlie Barnet Orchestra. In 1942, she made her first film, *Panama Hattie*. She starred in two all-black films, *Stormy Weather* and *Cabin in the Sky*. Other screen roles were limited by the racial attitudes of the era. After that, she was cast in films only as a nightclub singer when the films were shown in the South, where segregation was practiced. Other acts of discrimination got her interested in the civil rights movement of the 1950s and 1960s. Horne received Broadway's highest honor, the Tony Award. She also received the Kennedy Center Honors Award in 1984 for her achievements in the performing arts. She was presented with the Grammy Award for Lifetime Achievement in 1989. Horne died at age 93 on May 9, 2010.

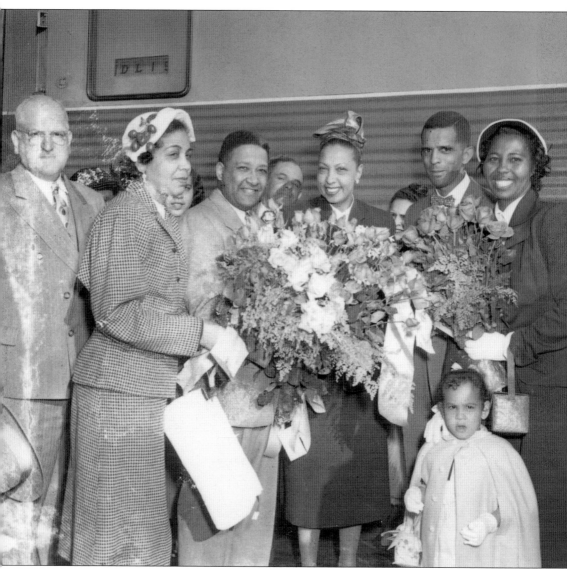

Welcome to San Francisco, Josephine Baker. Outstanding people throughout the Bay Area met Josephine Baker when she stepped off the San Francisco *Daylight* train. Born on June 3, 1906, Baker was a total entertainer. Her costumes were the highlight of her performances. She retired in Paris, where she housed many adopted children. Baker died on April 12, 1975. From left to right are R.J. Reynolds, of the NAACP; Myrtie Rector, a prominent businesswoman who was a great fan of Baker and brought flowers to her; unidentified; Baker; Franklin H. Williams, the western director of the NAACP; Mildred Brooks; and Pamela Lover, the three-year-old daughter of Mr. and Mrs. Al Lover of San Francisco.

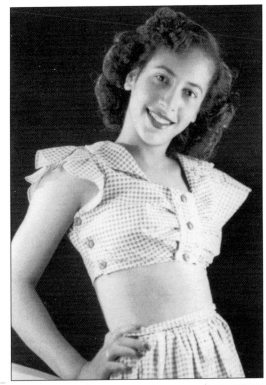

J. California Cooper was born in 1931 in Berkeley, California. Her father, Joseph, worked in the scrap metal industry, and her mother, Maxine, worked as a welder during World War II. After the war, she opened a beauty salon in 1947. Cooper wrote short stories and novels. Both Laura Bush, former first lady, and Alice Walker, Pulitzer Prize–winning author of *The Color Purple*, were fans of her writing. Walker published Cooper's first short stories through her company Wild Trees Press. Her short story *Funny Valentine* was made into a film. Cooper died in 2014.

Katherine Dunham was born in Glen Ellyn, Illinois, on June 22, 1909. As a student of anthropology at the University in Chicago, she realized that most Americans were ignorant of the African roots of popular dance. Dunham was the first to combine her knowledge of anthropology with the folklore of the Caribbean Islands. She was especially fascinated with Haitian dance. Her skill as a dancer led her to create her famous "Dunham Barre," which was a challenge for all dancers. In 1943, strong dancers, skilled drummers, and rich costumes designed by her husband, John Pratt, treated her worldwide audiences to unforgettable experiences, as seen here. Her successful concerts educated audiences to what she called "total theater." Dunham died on May 21, 2006.

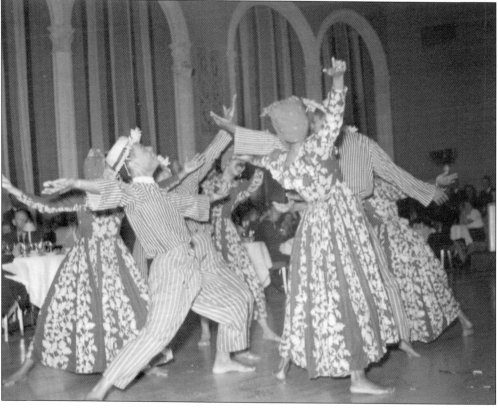

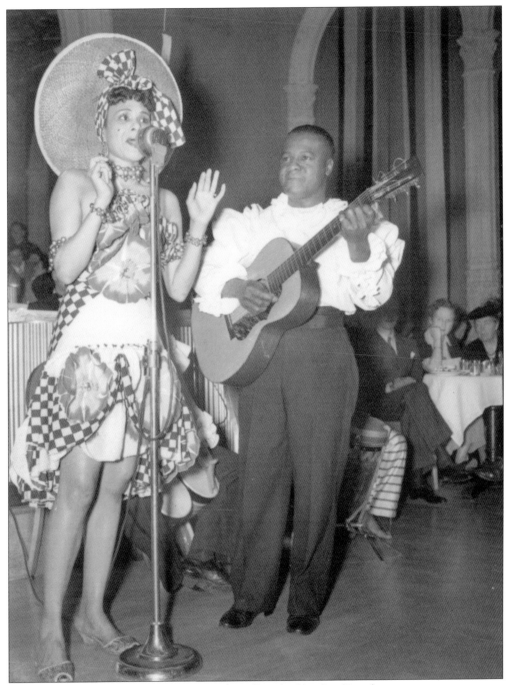

Dunham's beautiful legs were insured for $1 million by Lloyd's of London.

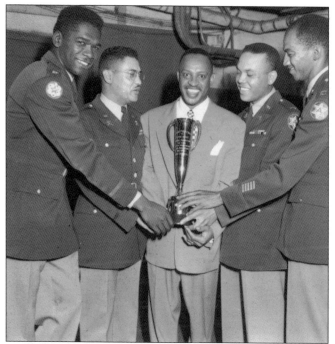

Lionel "Hamp" Hampton, born on April 20, 1908, was a master of the xylophone—not a popular instrument. As he played, he accompanied himself with his gravel hum. He moved smoothly from the treble to the bass keyboard. His band was composed of all master musicians. Above, members of the Bay Area Disc Jockeys honored Hampton on his 10th anniversary when he appeared at the Golden Gate Theatre in San Francisco. A huge cake complete with candles was presented to Hampton, along with a loving cup on the stage of the theater.

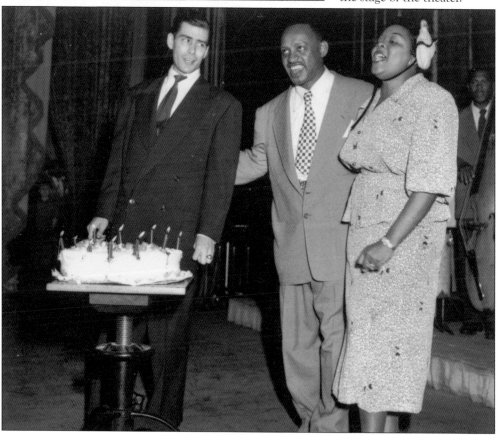

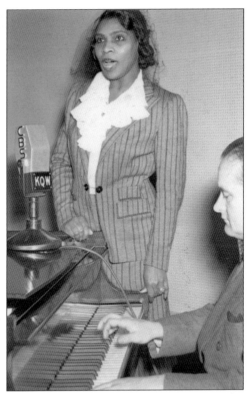

Born on February 27, 1891, Marion Anderson's elegance captured her audience as soon as she entered the stage. Growing up in Philadelphia, she had no idea of the courage she would need, given the discrimination of black women in the art of singing. Her contralto voice range was unmatched from opera to black spirituals. She captured her audiences when they heard her first note. She was invited to sing at the DAR Constitution Hall, but her performance was canceled when the Daughters of the American Revolution rejected Anderson because of her race. Former first lady Eleanor Roosevelt was a member of the DAR and resigned in protest to their discriminatory policy. Roosevelt arranged for Anderson to perform at the Lincoln Memorial. The 1939 open-air concert was a great success, with 75,000 people in attendance. During her career, Anderson was famous for her renditions of "Nobody Knows the Trouble I've Seen" and "Sometimes I Feel Like a Motherless Child." She was one of the first recipients of the Distinguished Kennedy Center Award in 1978. Anderson died on April 18, 1993.

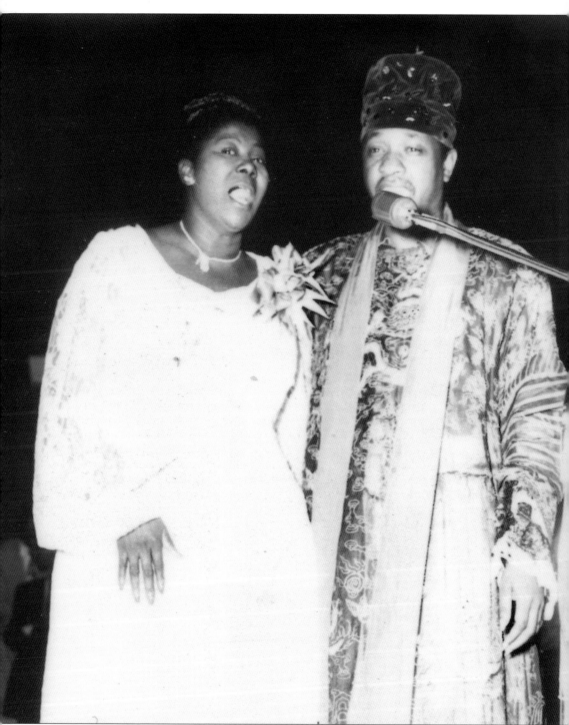

Mahalia Jackson was born in New Orleans on October 26, 1911. She had a powerful contralto voice. She was a true artist who put her soul into every performance. Gospel music was her gift. Earlier in her career, she gathered fans who were previously not followers of Gospel music. She was also a civil rights activist.

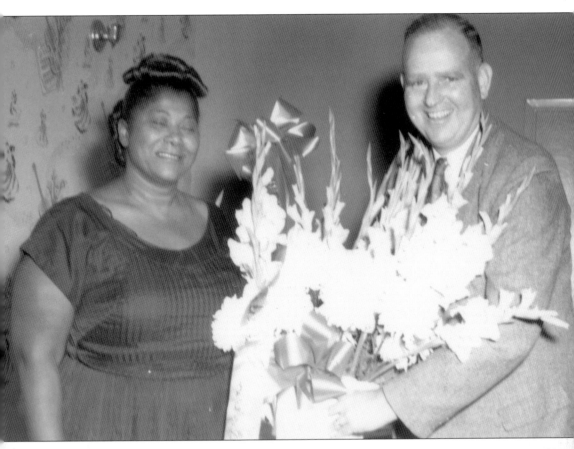

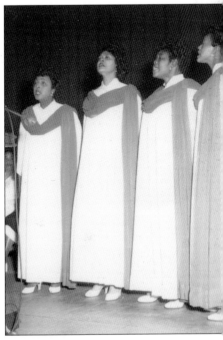

Ruth Beckford was born on December 7, 1925, and starting at three years old, she studied all forms of dance from the top teacher in Oakland, Florell Batsford. As her only black student, Beckford received private lessons, which only worked to her advantage. The white parents were shocked to see her in the dance recitals and even more surprised to see her received the biggest applause. With a very flexible body, Beckford concentrated on acrobatics. She continued to study with Batsford until age 17, briefly leaving to tour with the company of her mentor, Katherine Dunham, in Canada. Beckford left the University of California, Berkeley, to become the founder of the Oakland Recreation Department's Modern Dance, the first of its kind in the country. She focused on life skills, along with dance. Her 20 years there, from 1947 to 1967, were her proudest contribution to dance and the lives of many young ladies. In 1962, she retired from her successful African Haitian Dance Company. In 1975, she closed her studios in San Francisco and Oakland and said good-bye to 47 years of dance. In Beckford's words, "I've had a blessed, successful career. I believe you should stop while you're still on top, and I did." Beckford is pictured here as a young dancer in 1933.

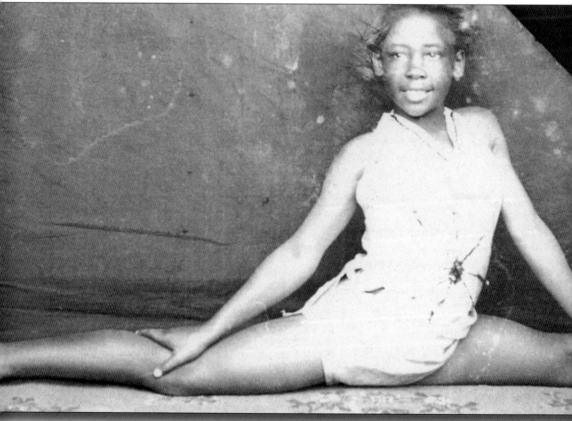

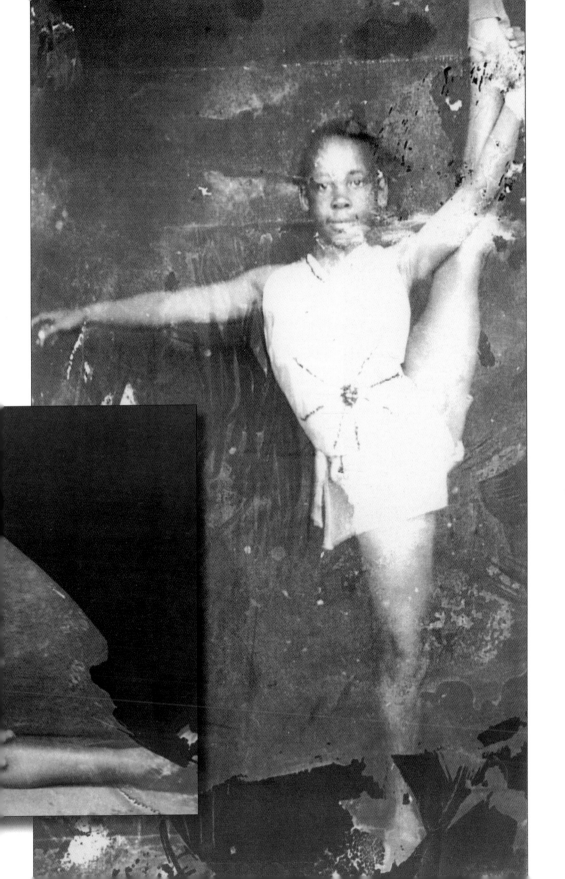

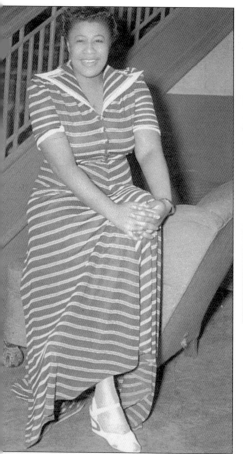

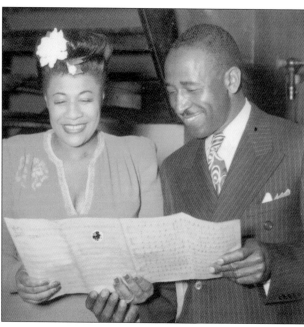

American jazz singer Ella Jane Fitzgerald, born in 1918, is often referred to as the "First Lady of Song" or "Queen of Jazz." She is best known for the song "My Funny Valentine." Fitzgerald died on June 15, 1996, in Beverly Hills, California. She is shown above with her manager, Mr. Williams. She famously sang with the Ink Spots (pictured below).

A favorite actress in movies, television, and radio, Louise Beavers (1902–1962) visited San Francisco to attend an elaborate dinner as the guest of honor at the home of Roger and Gertrude Druhet. She is seen wearing the large hat and double corsage. The Druhets were well known in business, church, and social circles in San Francisco and were famous hosts.

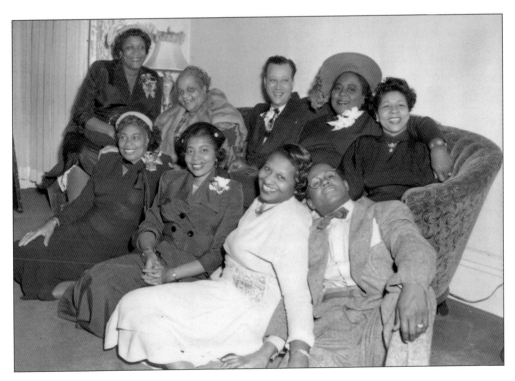

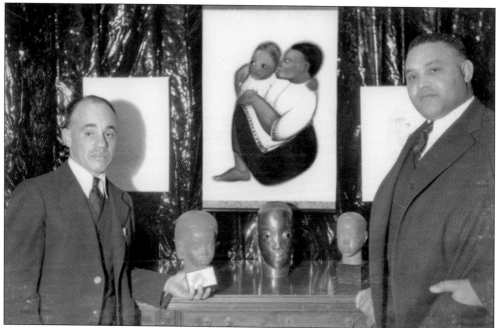

Sargent Johnson (left) is pictured here with Walter Gordon (right). Johnson had sculpted a bust form of Gordon's son Edward. Born on October 7, 1888, Johnson lived on Parker Street around the corner from author Careth "Diddy" Bomar's home on Acton Street. Diddy used to go climb the fence around Johnson's backyard to watch him work on his sculptures. Johnson had a stool that he dropped over the fence so she could stand on it to see him better. Diddy was six years old when Johnson worked on the pieces he made for the 1935 World's Fair on Treasure Island. He also made the exterior murals on the Maritime Museum in San Francisco. Johnson died on October 10, 1967.

Three

BUSINESS

Joseph was the go-to photographer in the Bay Area, as he could guarantee that individuals and groups would have their pictures and information published in the *Chicago Defender* newspaper. The paper's policy was opposed to lynching and Jim Crow laws, which enforced segregated housing, restaurants, bathrooms, and anything else that could be segregated. Joseph photographed family celebrations, social parties, church documentation, business openings, and the like. Robert Abbott founded the paper in 1905 and used it to challenge the nation that failed to live up to its ideals. Abbott's nephew John H. Sengstacke took over the paper and continued his uncle's policies.

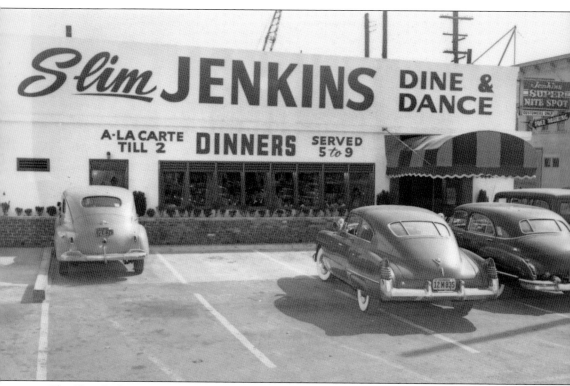

The Slim Jenkins restaurant, cocktail lounge, and bar, pictured here in 1950, dominated the corner of Seventh and Wood Streets in West Oakland. Whether a doctor or a janitor at the Naval Supply Depot on the waterfront, it was the meeting place for everyone. Slim's had a well-known standard of class. No one went there in coveralls or work clothes. The bartenders knew the names of their patrons, and they made the best pink ladies or scotch-and-milk drinks. The long bar was a separate space with fancy lighting. The booths and tables of the restaurant created a cozy ambiance, and the food was outstanding. The cocktail lounge was a large room with soft lighting and its own bar. Tables and booths were scattered around a small dance floor. The stage completed the sleek atmosphere, which often featured up-and-coming national stars.

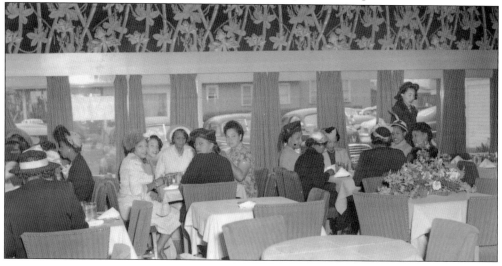

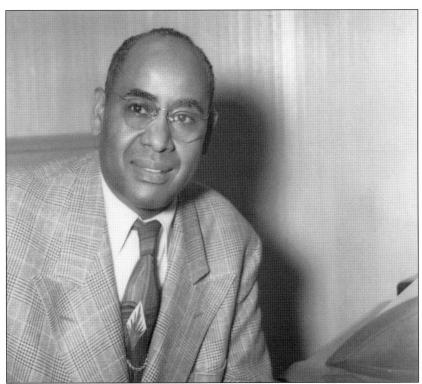

Born on July 22, 1890, Harold "Slim" Jenkins grew up in Monroe, Louisiana, knowing that he wanted to be in the restaurant business. In 1933, he came to Oakland and opened Slim Jenkins. He was an imposing, slim figure at six foot five, with a dark-brown complexion and always an unlit cigar in his mouth. He was well dressed in a suit, often with a vest that held his watch chain in the pocket. Jenkins was a no-nonsense man, totally focused on his business. He could make the rich pimp or the most respected lawyer feel important and comfortable. He migrated between the three areas of his establishment—the bar, restaurant, and cocktail lounge—squeezing hands and making his customers feel special. Folks came to his club from as far as New York or Atlanta. In 1962, Jenkins moved his business to Broadway in downtown Oakland, near London Square. However, it was never like the original Slim's on Seventh Street. Jenkins died on May 24, 1967.

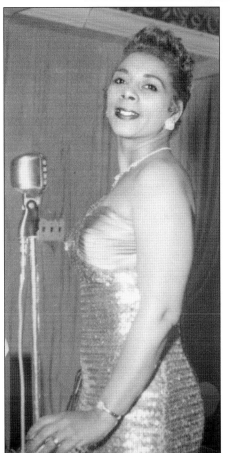

Slim's entertainers had talent and class. Beauty was often a part of the package.

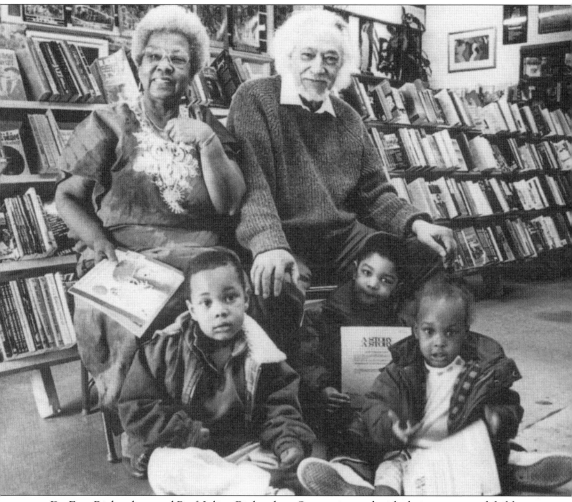

Dr. Faye Richardson and Prof. Julian Richardson Sr. are pictured with their great-grandchildren at the San Francisco location of their store Marcus Books in 1983. Blanche, their daughter, manages their Oakland store on Martin Luther King Jr. Way. California Cooper, the writer, frequented the Oakland location to do her research.

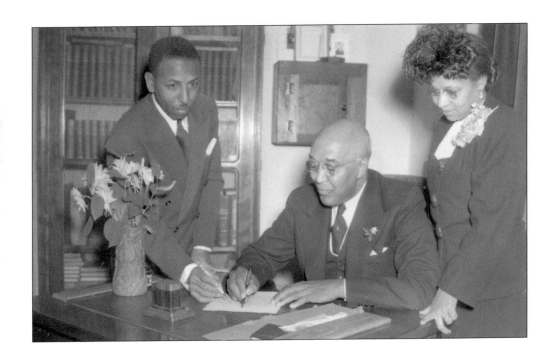

Reverend Bell and his wife are pictured with John Ware at the Carver National Insurance Company on December 15, 1945.

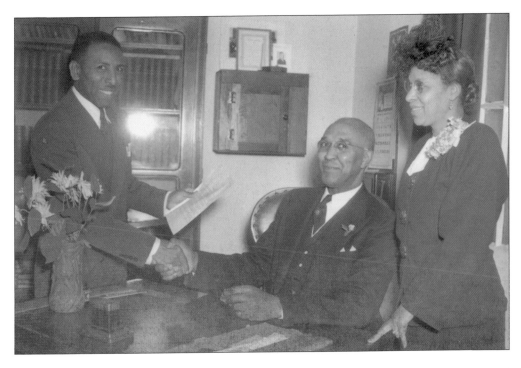

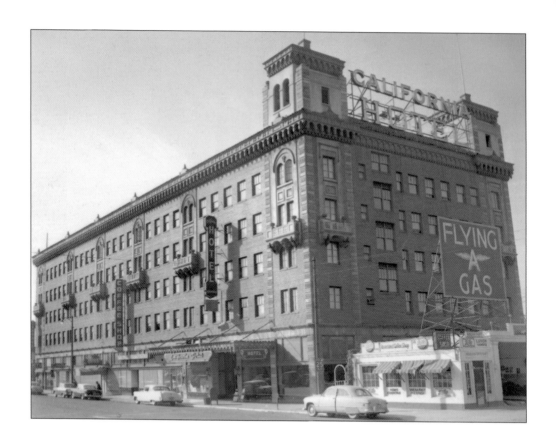

The California Hotel was a large five-story brick building at 3501 San Pablo Avenue in North Oakland. It was the place to go for a good time.

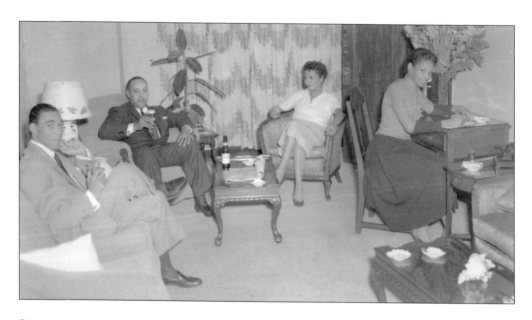

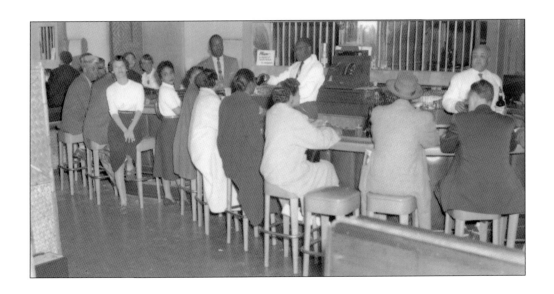

The lobby of the California Hotel was all glass with period architecture. Comfortable lounge sofas and chairs gave the room a classy look. The check-in desk was situated in the far corner, where the bellhop always stood. The Gold Room and a florist were located off the lobby. Every Sunday afternoon, the Gold Room held its famous mambo sessions in the early evening. Folks came dressed up and looking good. The house band for the sessions was that of Carlos Federicos. A restaurant was also housed on the lobby level. Through the restaurant was a nightclub barroom. A barbershop and other offices were found on the mezzanine. Most visiting celebrities stayed in one of the penthouses.

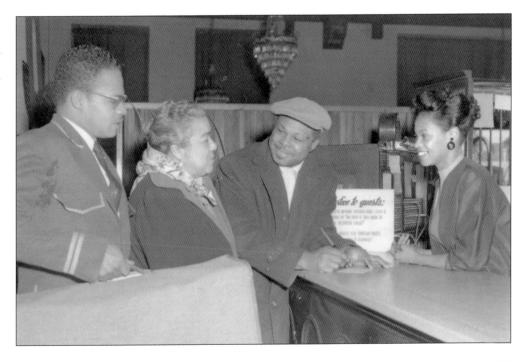

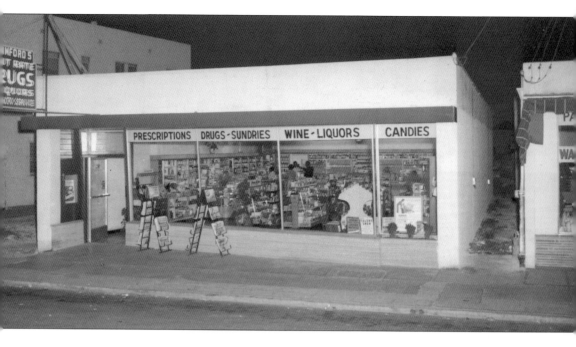

In 1951, Rumford's Pharmacy on Sacramento Street was the only black drugstore in Berkeley.

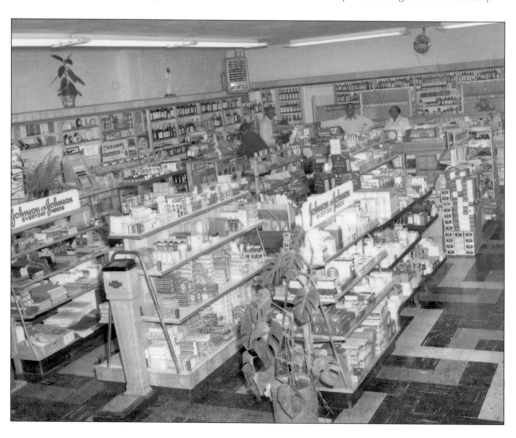

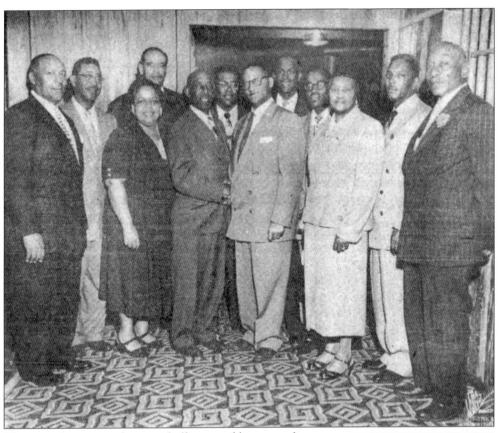

The annual meeting, election of officers, and banquet of the California Morticians Association were held at Slim Jenkins' new Casablanca Room in Oakland on Saturday, January 23, 1945.

MORTICIANS DINE AND ELECT (Pictured at left)—DENNIS MATTHEWS, outgoing president, is seen (center) congratulating CECIL L. FINLEY, newly elected president, of the CALIFORNIA MORTICIANS ASSOCIATION, at their annual meeting, election of officers and banquet, held at Slim Jenkins' new CASABLANCA ROOM, Oakland, Saturday afternoon and evening, January 23.

Officers and Board Directors are (left to right) ARAMIS FOUCHE, director, Oakland; LEE GRIGSBY, recording secretary, Los Angeles; SAMUEL COLEMAN, director, San Francisco; MR. MATTHEWS, Los Angeles; THEODORE THOMPSON, director, Sacramento; MR. FINLEY, owner Butler Funeral Home, San Francisco; FREDERICK VALENTINE, director, Pasadena; EDWIN BAKER, vice president, Oakland; ANNA MAE WOODS, treasurer; Pasadena; DELL RUCKER, director, Bakersfield, and CHARLES BAKER, director, Oakland.

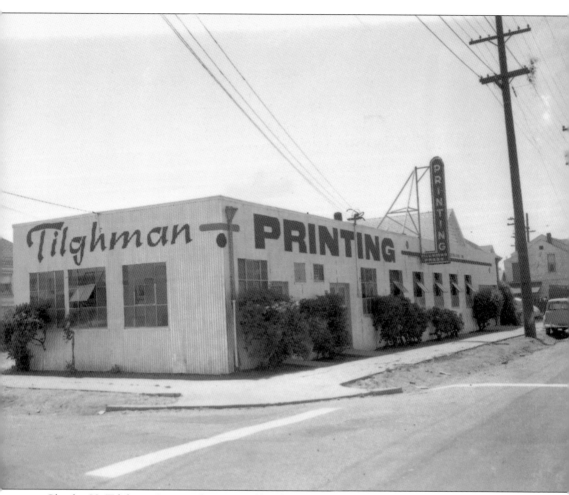

Charles H. Tilghman's print shop in Oakland was rich with the history of the community. He was the printer for all events, from weddings to graduations and funerals to births. His shop was crowded with printing presses, tables, and files. The smell of ink permeated the shop. Tilghman always looked like a true printer in his ink-stained apron. Always a talker, he loved to go into details of his latest job. This photograph was taken on July 18, 1955.

Four

CHURCHES

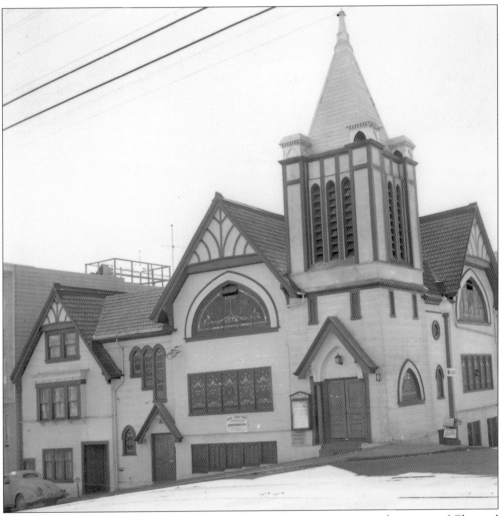

The Third Baptist Church had a large congregation from its opening on the corner of Clay and Hyde Streets to its present location at McAllister and Pierce Streets in the Fillmore District. The congregation boasts an outstanding junior and senior choir. Bible study is held during the week and is always well attended. The smartly dressed ushers were on hand if a member of the congregation gets "taken by the spirit."

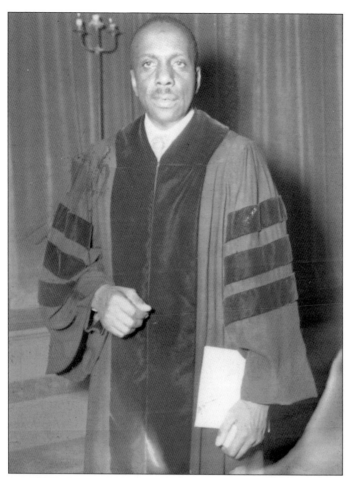

The Reverend Howard Washington Thurman, born on November 18, 1899, was one of the leading figures of religion in the 20th century. He was the first dean of Rankin Chapel at Howard University's School of Religion. He left Howard in 1944 to establish the first interracial, interdenominational, nonsectarian church in San Francisco with Alfred Fisk. Located at 2041 Larkin Street, the church was called the Faith Fellowship for All Peoples. Reverend Thurman died on April 10, 1981.

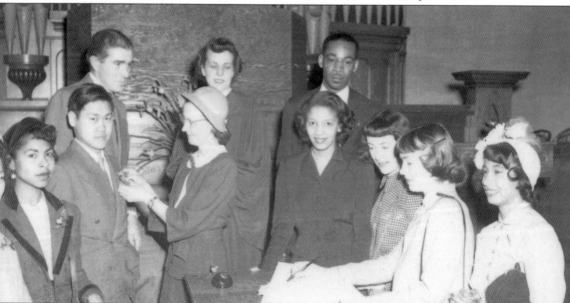

The Taylor Memorial Methodist Church at 1188 Twelfth Street in Oakland is pictured here on March 11, 1944.

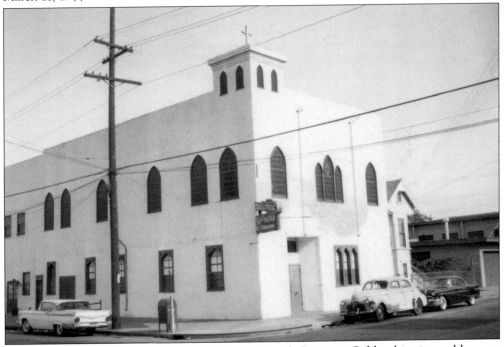

The Solid Rock Baptist Church at 938 Twenty-Fourth Street in Oakland is pictured here on November 28, 1960.

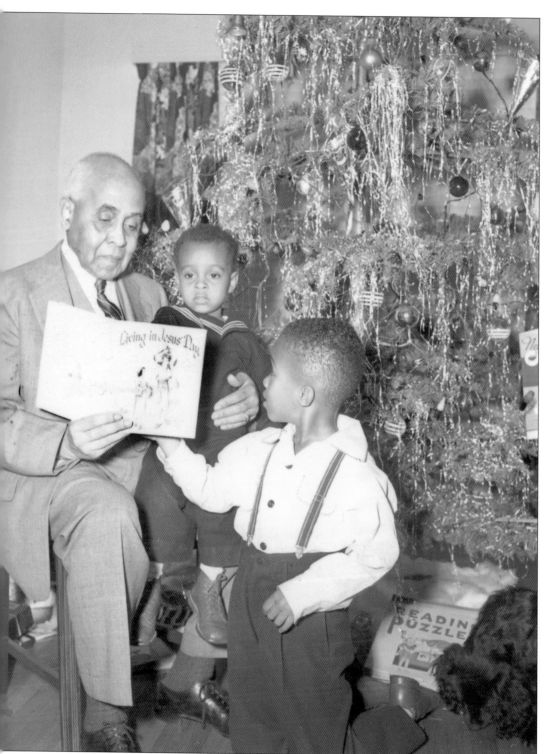

The Reverend A.A. Moore is pictured with his grandsons at their home on Dohr Street in Berkeley on Christmas 1949. He was the pastor of the Taylor Memorial Methodist Church in Oakland.

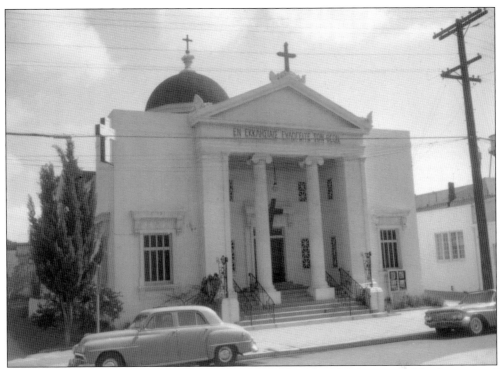

The Greater St. Paul Missionary Baptist Church at Tenth and Bush Streets in Oakland is pictured here on March 10, 1961.

The Bethany Baptist Church at 1904 Adeline Street in Oakland is pictured here on November 23, 1964.

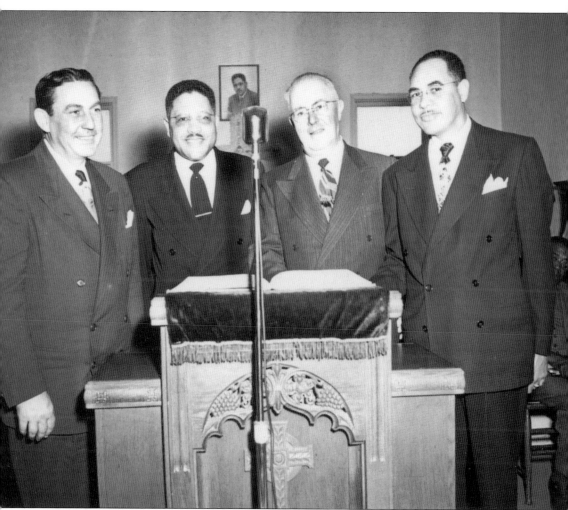

The Reverend H.W. Watson, pastor of the New Hope Baptist Church in Oakland, turned over his regular Sunday-morning service to attorney general Fred Howser, who spoke on narcotics and the degeneration that comes with its uses. He emphasized the need for more agents in the department and more schools and facilities in the school system. He said that juvenile delinquency comes from the lack of parental supervision, and he appealed to fathers and mothers of teenagers to cooperate with teachers to improve the delinquency problem of the state. During the war years, the conflict's influence was the primary factor in juvenile delinquency, which decreased after the war. The traffic in the illicit use of opium, heroin, morphine, and marijuana, the latter mostly used by teenagers, had also contributed to delinquency. In his closing remarks, Howser brought a round of excited amens from the crowded New Hope Church when he said, "I am happy to report to you that in the official records of the three leading groups, the Negro delinquency in narcotics is the least used, a tribute to the Negro family." From left to right, Attorney General Howser is congratulated on his fine speech by Reverend Watson; Walter R. Creighton, chief of the Division of the Narcotic Enforcement Department of the Justice of the State of California; and W. Byron Rumford, assemblyman for the 17th Assembly District of California.

Five

CIVIL RIGHTS

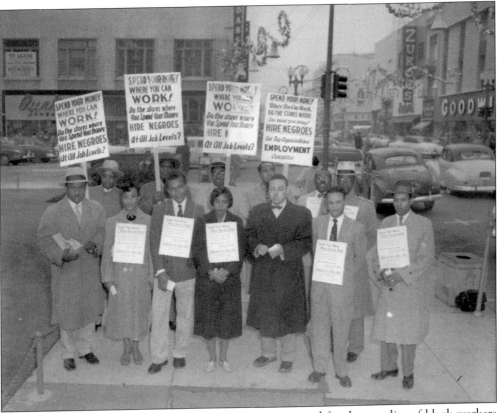

The East Bay Organizers Employment Committee protested for the equality of black workers on December 12, 1955. The call to action on their signs read, "Spend your money where you can work! Do the stores where you spend your money hire Negroes at all job levels?" Located at 1314 Ashby Avenue in Berkeley, the committee was composed of ministers, civic leaders, fraternal groups, and the NAACP, with the following officers: Rev. H. Solomon Hill, chairman; Neitha Williams, secretary; Rev. Edward Stovall, chairman of the education committee; and Mrs. Frances Albrier.

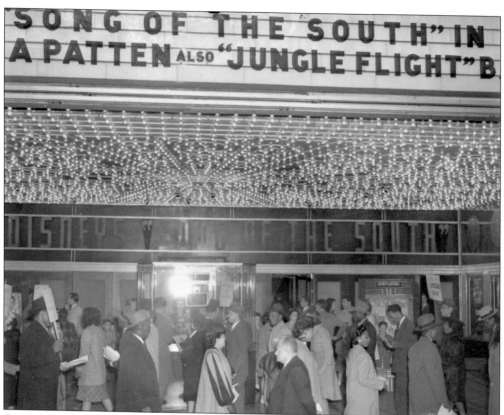

On April 2, 1947, protestors marched outside the Paramount Theatre in downtown Oakland, bearing signs that read, "We want films on democracy not slavery," and "Don't prejudice your child's mind with films like this." Below, Paul Robeson and his wife are pictured with Ray Thompson.

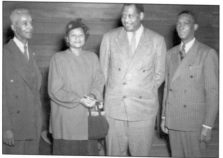

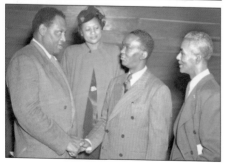

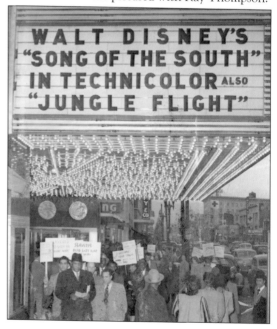

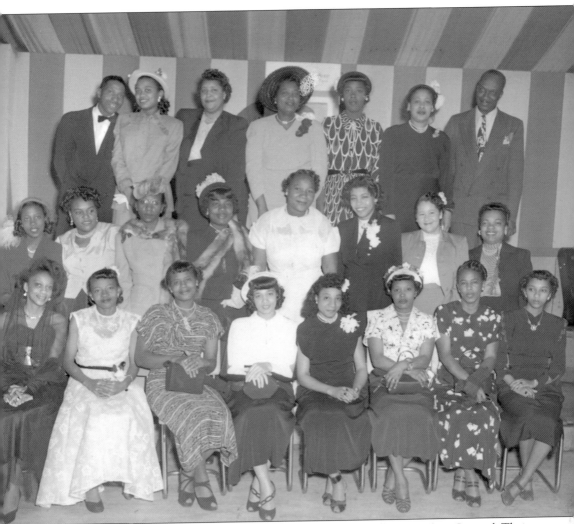

Local post office employees organized the San Francisco–Bay Area Postal Workers Council. Their purpose was to curtail the wholesale layoffs of war service indefinite appointees in the city's post office after the war, the majority being black women. They hosted a cocktail party to raise funds to send a lobbyist to Washington, DC, in an attempt to get a bill passed to give noncompetitive examinations. Pictured are the ardent workers Lillian Brown, M. Cleaner, Sarah Payne, Mary Lou Saddler, Jo Ann Taylor, Eula Mae Brooks, Jerry Fisher, Connie Whitmore, Lola Fillden, Velma Richardson, Rosie Davis, Emma Lee Logan, Elsa Dugas, Betty Jo Ashlery, T. Williams, Bobbie Jackson, Bessie Sanders, Mildred Hatton, Flortine Richardson, Olive Holliman, and executive director Charles F. Augustus. In the second row, the women on the far left and far right are unidentified.

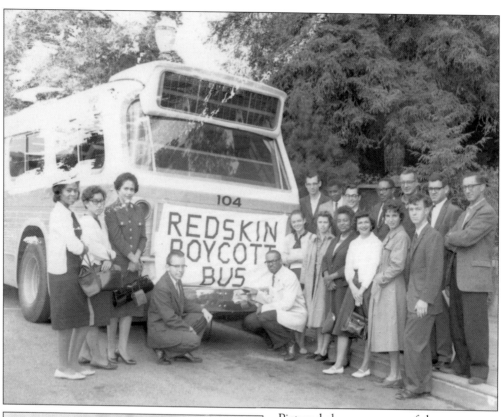

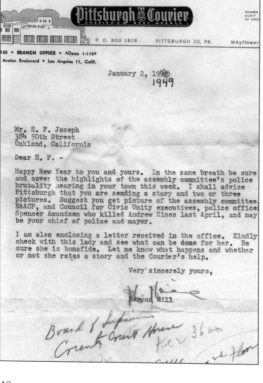

Pictured above are some of the more than 100 people who took part in protesting the discriminatory hiring policy of the Washington Redskins: "Redskins hire only White Skins." When their football team played the San Francisco 49ers at Kezar Stadium in California, pickets gathered near the University of California, Berkeley. Toney Salotto and John Taylor are some of the Berkeley members of CORE who had been arrested in southern states. This photograph, taken on September 17, 1961, marks the first time Freedom Riders picketed in northern states.

This letter from Herman Hill of the *Pittsburgh Courier*, sent to Joseph on January 2, 1949, suggests that he cover the interim committee for crime and correction.

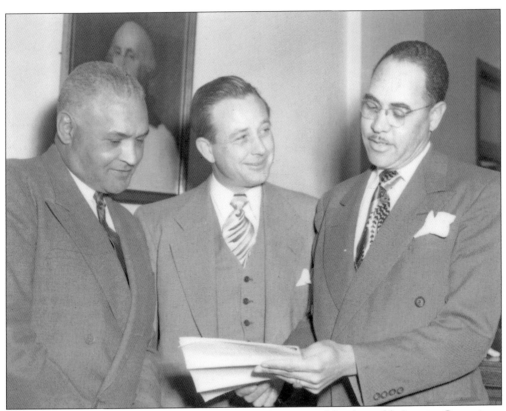

In 1949, Vernon Kilpatrick, pictured at left below, chairman of the Assembly Interim Committee on Crime and Correction, promised a fair and impartial hearing in regard to charges brought against the Oakland Police Department (OPD) for disregarding the civil rights of blacks and discriminating against them. In the photograph above, attorney Walter A. Gordon (left), chairman of the California Adult Authority, and policy chief Lester Divine (center) listen to assemblyman Byron Rumford (right) as he explains his view and recommendations. Gordon, pictured at center below, provided the investigating committee with instances where the OPD had been lacking in their protection of the life and property of blacks, in addition to making the following statement: "The Negro policeman should not be segregated in the West Oakland area but should be assigned along with the white policy officers in the downtown areas, as well as any district. Just being a Negro has given me experience in race relations." Oakland mayor Clifford E. Rishell, pictured at right below, also participated in the proceedings.

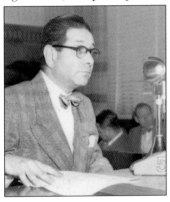
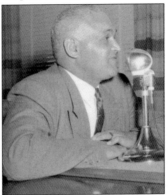
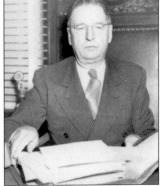

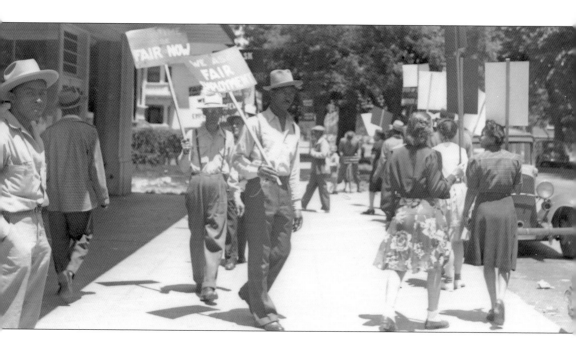

In 1944, the community banded together to picket Safeway Stores, asking for fair employment.

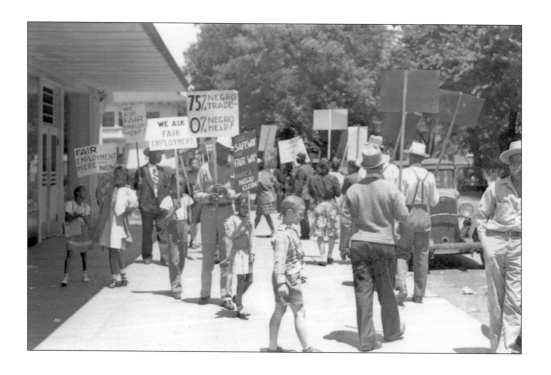

Six

CLUBS

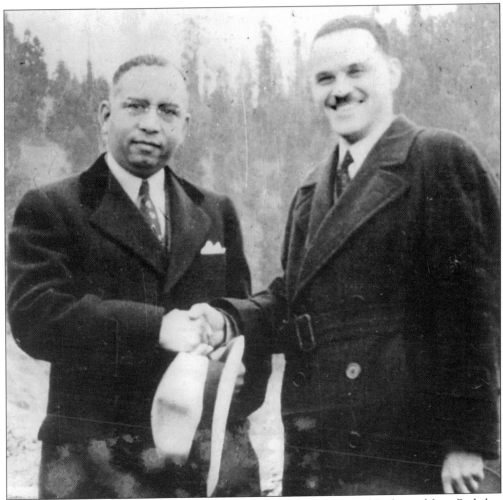

Dr. Rod Brown (left) from Pittsburgh, Pennsylvania, and Dr. Arthur Earl Rickmond from Berkeley, California, are pictured at Mount Diablo. Dr. Brown's wife, Lillian, set up East Bay Links, the first Links chapter on the West Coast.

The Links Inc. issued the following statement titled "Our Thanks" in 1959: "We wish to extend sincere greetings and thanks to all of you, our loyal friends who have supported us through the years in our philanthropic efforts. Through you, we the Oakland Area Links have presented substantial checks each year to the NAACP, the Eastbury Activity Center for Emotionally Disturbed Children, and the Lighthouse for the Blind in San Francisco. For this, we are humbly grateful. To the parents of our lovely debutantes, we offer congratulations. We are very pleased to have

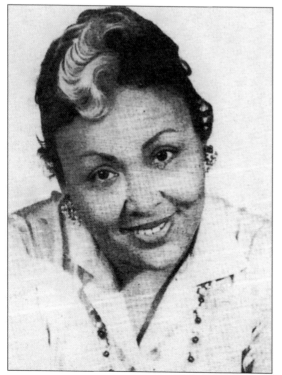

the privilege of presenting your daughters of the community tonight in our fourth Cotillion. In bringing these young ladies before you, we only hope that in some small way we are helping them to build a better foundation of faith and an understanding of their responsibility for heightening the cultural and social life in our community. We are proud of them as you, their parents. Nationally, The Links are conducting a research program in a study on 'Gifted' youth. Upon the publication of our findings, we hope to provide more opportunities for the development of these talented boys and girls. We have 95 chapters in 45 states participating in this project, which will be completed in 1962 at a cost of more than $16,000. May God keep and Bless you, each one. Again, our thanks."

Margaret Lewis served as president of Oakland–Bay Area Links.

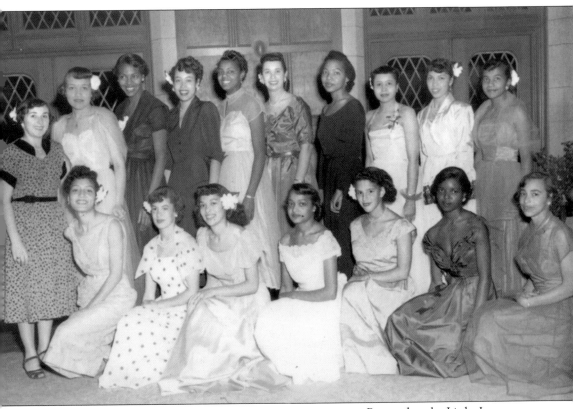

Pictured at the Links Inc. annual tea in 1951 are the aides of the event, gowned in colorful frocks. From left to right are (seated) Kay Frances Carroll, Ruth Dean, Myrtle Brown, Mildred Penn, Virginia Rose, Elberta Henderson, and Jean Young; (standing) Milou Rickmond, unidentified, Angelica Hulett, Lyta Marie Colman, Rose Mary Hulett, Andrea Rickmond, Evelyn Bridges, Bernice Jackson, Frishby Ann Lloyd, and Gaynell Williams.

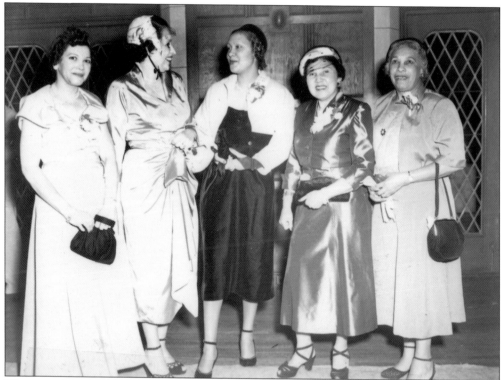

The second-annual tea of the Oakland–Bay Area chapter of the Links Inc. was one of the most outstanding affairs of the season. The Westminster House on the Berkeley campus of the University of California was the setting that brought together families and friends for the hours of the tea. Pictured at the event are, from left to right, Freda Bethel, recording secretary; Mrs. Charles Rogers, vice president of the Oakland chapter; Mrs. Herbert B. Henderson, corresponding secretary of the San Francisco chapter; Lorraine Rickmond, president of the Oakland–Bay Area chapter; and Margueritte Evans, who is an active member of the San Francisco chapter, organized in 1946.

The three lovely debutantes pictured here are, from left to right, Lina Lewis, Michelle Rickmond, and Beverly Neeley.

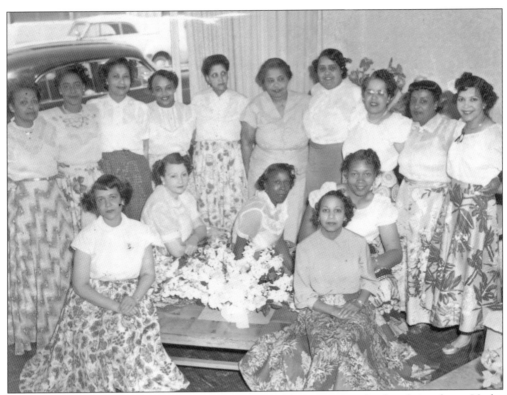

In 1913, a group of girls formed the Phyllis Wheatley Club to sew items for their hope chests. Under their first matron, they started knitting sweaters and socks for soldiers in the Colored Division of the Red Cross during World War II. The club also enjoyed house parties, picnics, and hikes. In 1915, Hettie B. Tilghman became their second matron, and they formed the California State Federation of Colored Women's Club. Initiation was 25¢, and monthly dues were 10¢. Member Victoria Francis was elected as the state recording secretary. In 1920, the first wedding occurred in the club. In 1938, they withdrew from the state federation but continued to support the Fannie Wall Children's Home and Day Nursery in Oakland, among others. Dressed in colored swing skirts, members of the Phyllis Wheatley Club of East Bay are shown here celebrating their sixth-annual flower show. They charged admission to the show to raise funds for their charities.

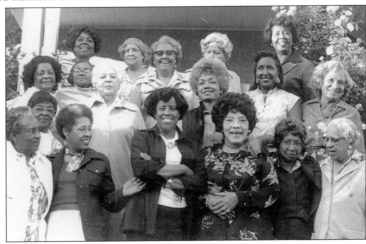

Oakland mayor Lionel Wilson proclaimed June 6, 1981, as Phyllis Wheatley Club Day of the East Bay.

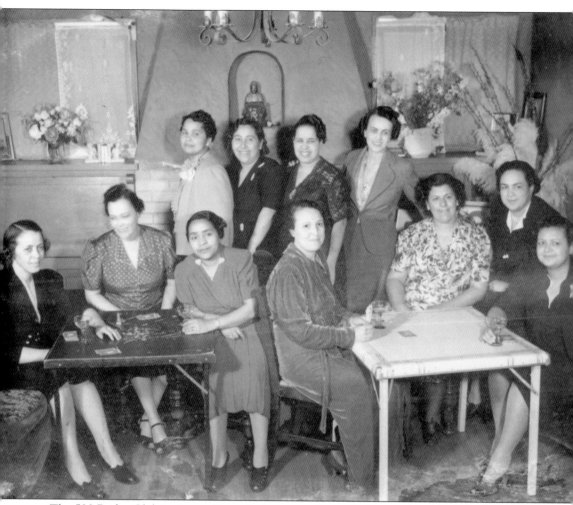

The 500 Bridge Club is pictured here during a meeting a the home of Beatrice Worth on Blake Street in Berkeley on May 11, 1939. Worth was known as "Bebe" to her good friends, whom she had known since childhood. She is seated in the center in a robe. She crocheted constantly when she was not playing cards and drinking. Bebe was a party girl. Dr. Arthur Earl Rickmond and his wife, Lorraine, a concert pianist, lived with Bebe. Many families shared housing during the Depression so that they could pay their mortgage, and when World War II started in 1941, the increased population due to the war industries led to a housing shortage. Bebe's husband was a musician in the US Navy, so she did not want to live alone during the war.

Seven

FAMILY

Jasper Bailey's son is being christened with the help of his grandparents, dressed in their best for this special occasion on April 11, 1948.

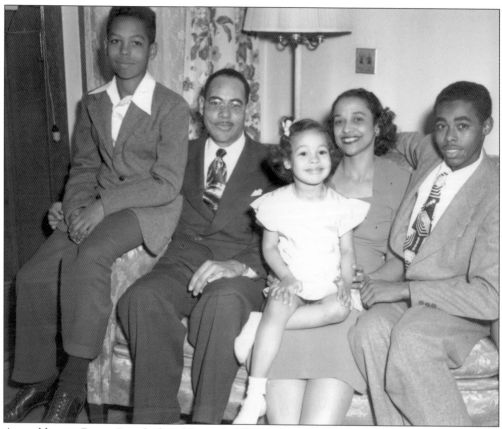

Assemblyman Byron Rumford and his wife, Elsie, are pictured above with their daughter and two sons on December 22, 1948. Their son Randolf Rumford (pictured below left as a baby and below right as a young man), born on December 7, 1936, drowned in Lake Temescal in Oakland on July 4, 1959.

The Fleming family is pictured at right on March 5, 1950.

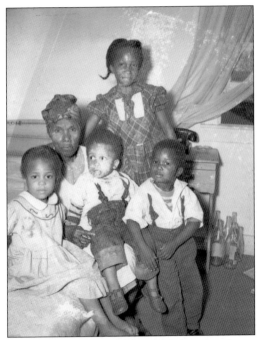

Mrs. G.M. Bell lived in a beautiful home on Sutter Street in San Francisco with her family. She is pictured below with an unidentified woman on January 21, 1946.

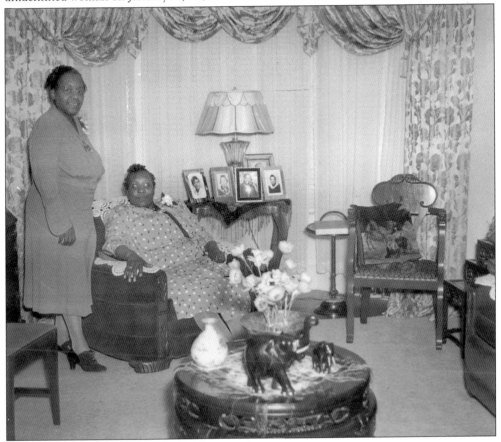

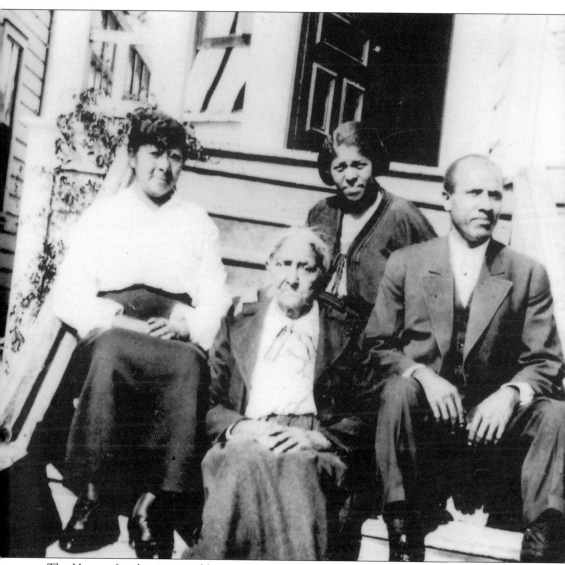

The Hoover family is pictured here in Alameda, California, in 1930. From left to right are Ella Hoover (daughter), Sylvia Buck Hoover (mother), Sylvia Turner Scott (granddaughter), and William Hoover (son). They were refugees from Lexington, Mississippi. William Hoover got a job as a porter on the Southern Pacific Railroad, and when his father died in 1902, he brought his mother to California. She was born into slavery and stayed with the Buck daughter, whom she was given to at eight years old as her dowry when she wed. This is the family of Merrill Hoover, the pianist who toured with Anita O'Day for years and who played for Billie Holiday. He worked for Bix Nightclub in downtown San Francisco for more than 14 years.

Joshua Rose is pictured with his two children on February 26, 1939. His wife Virginia is also seen here on November 29, 1942. Below, their family has grown to include three children.

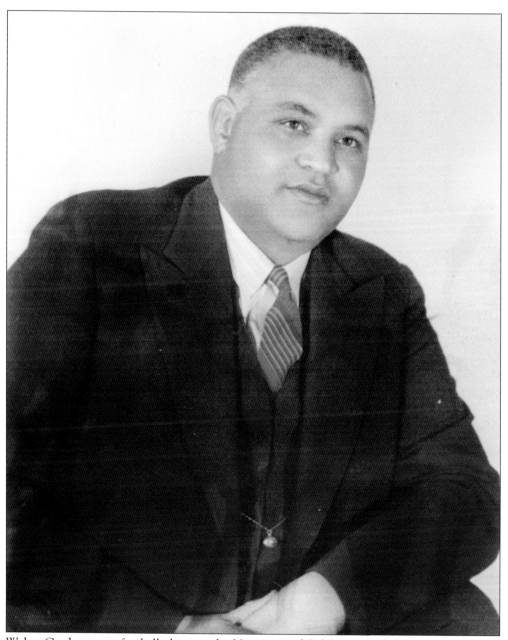

Walter Gordon was a football player at the University of California, Berkeley, in 1936. Careth Bomar was five years old at the time; her nickname was "Diddy." On Sundays, Diddy would get into bed between Walter and Elizabeth Gordon, who lived across the street. While Elizabeth would be knitting and smoking, Walter would read the funny papers to Diddy. He went to law school at Cal. The Gordons had three children, Walter Jr., Ed, and Betty, who was Diddy's friend.

Eight

GLAMOUR GIRLS

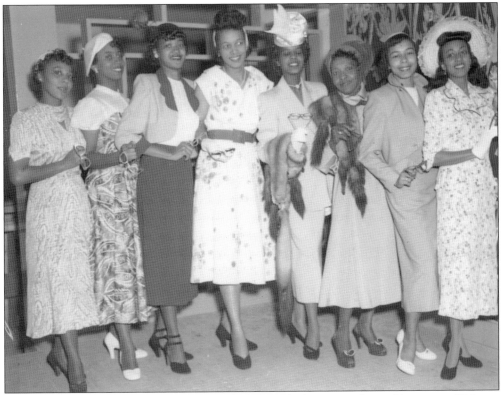

During World War II, good jobs brought good salaries, which meant a disposable income. This was a first for many of the "newcomers" who had migrated to the North. Men opted for fancy cars, but women saw it as a time to shop and glamorize themselves. I. Magnin, a store on Broadway in downtown Oakland, became the popular hangout. Sunday mornings at church became a fashion show, and the competition was fierce. Of course, the pastor's wife was always decked out from head to toe. The women in the choir could not wait for church to let out so that they could take off their robes and join the congregation in their parade of fabulous outfits. Slim's on Seventh Street became the official fashion show headquarters. Some women took modeling classes from Annette Bruce, then the most popular fashion teacher. Others felt they had their own swag and did not need a teacher. Whether a model or a glamorous observer, everyone enjoyed the shows.

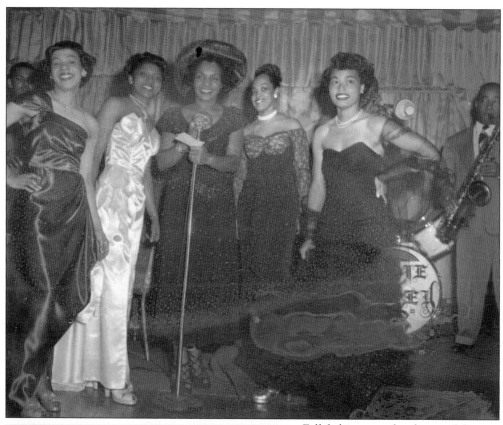

Fall fashion was the theme of the 13 Charms Club fashion show at the California Theatre restaurant in San Francisco. Models paraded down the runways in afternoon and evening attire. From left to right are club members Clemmie Dantlay in a satin and lace party frock, Geneva Pollard in white, announcer Flo Allen, Valda Wilson in a lace dress, and an unidentified woman. The club was established on September 17, 1953, and Pollard was its first president. The model below is Annette Bruce, with the club's mascot dog.

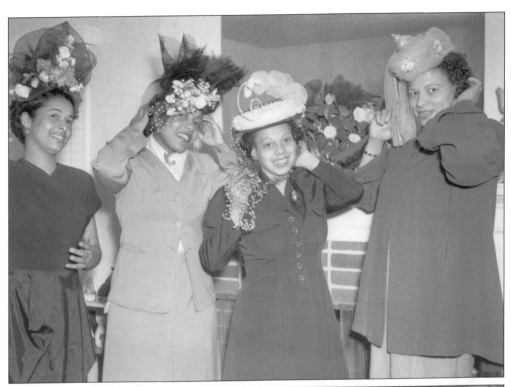

Annette Bruce (left) and friends are happy to show off their Easter bonnets in 1952.

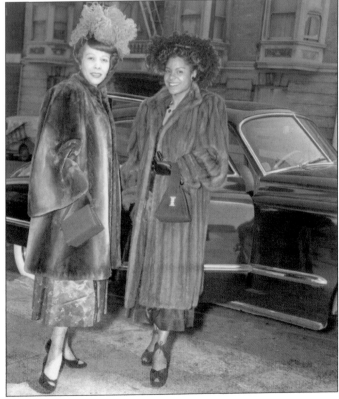

Two customers strike a pose outside Davis Furrier at 746 Post Street on April 7, 1949. On the left is a two-tone beaver coat, and the mink coat at right has full sleeves and pointed lapels. Owning a fur coat was symbol of high status.

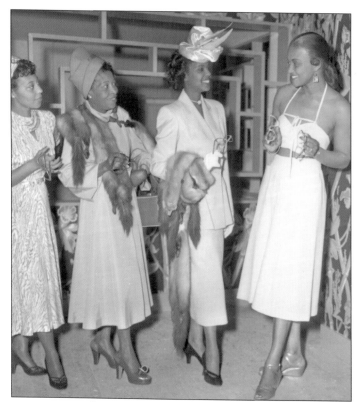

Josephine Humprey's models are posed in these casual fox and stone marten fur stoles on April 26, 1950. Whether slung over the arm or the shoulder, the mouth could be clipped to the tail for a varied look.

Ruth Acty was the first black teacher in Berkeley, California. She was hired as a kindergarten teacher at Longfellow School on Sacramento Street. She had a little student whose arms stopped at the elbows, with his fingers sprouting out at the end. His mother had named him Rooster. He was teased at school every day, so Acty got permission from his family to let him change his name. He chose Robert, and she paid to have it changed legally. This photograph was taken on December 31, 1945.

Nine

GREEK LIFE

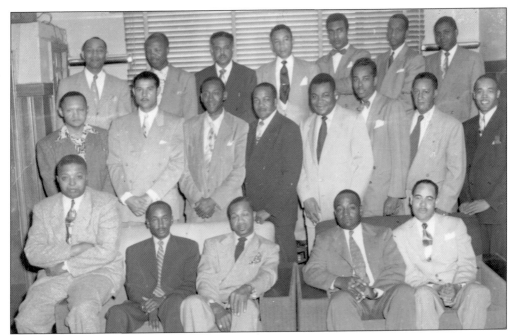

Members of Alpha Phi Alpha are pictured here. These fraternities and sororities were private organizations, and because of that, some folks considered them to be snooty. The main San Francisco Bay Area colleges at the time were the University of California, Berkeley, and the San Francisco State Teachers College, now called San Francisco State University. Known by their Greek letters, these organizations were actively involved in positive community service events and thus were leaders in their communities. To become a member, one was put through the traces of pledging, which meant being subservient to the established members. Pledges were often required to perform embarrassing acts, such as sitting on Santa's lap in a large department store, or conduct routine chores like washing the cars of their superiors. The fraternities' male pledges were subjected to paddle whipping if they didn't follow the rules. Some of the sororities would not pledge anyone who was a few shades too dark, which only led them to miss out on many talented women.

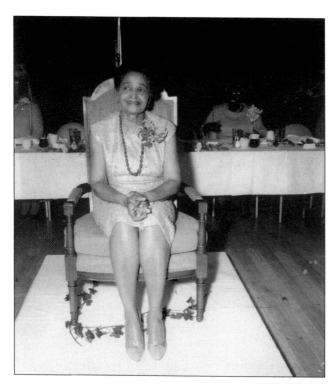

Ida Jackson cofounded the Alpha Kappa Alpha (AKA) sorority with Virginia Stephens. Jackson graduated from the University of California and went on to become the first black teacher in Oakland. She obtained a principal certification in 1936. Here, Jackson is the guest of honor at the AKA This Is Your Life event at the Holiday Inn in Emeryville, California.

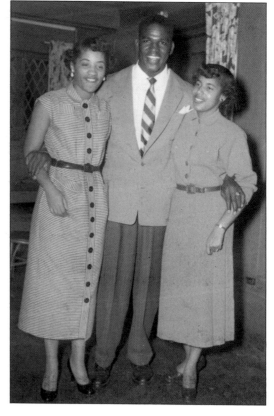

The Kappa chapter of the Delta Sigma Theta sorority hosted the Football Dance in the Palm Room of the YMCA in Berkeley. The event brought together many of the prominent West Coast football players and their friends. Enjoying the dance are, from left to right, Gloria Keith, Burl Toller, and Melvia Toller.

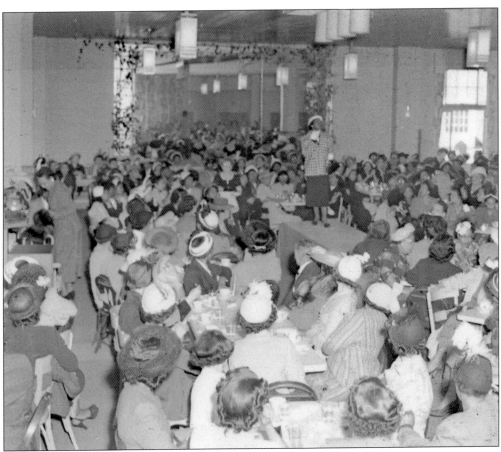

The AKA sorority organized a summer fashion show with 500 people in attendance to raise funds for their scholarship program. The swank restaurant on the roof of the H.C. Capwell store on Broadway in Oakland was the venue.

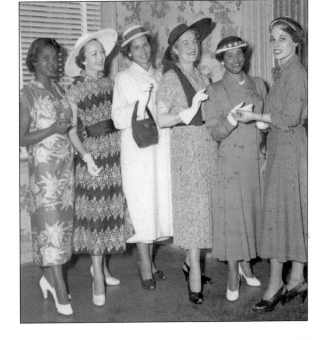

This interracial group of attractive models includes, from left to right, Elberta Henderson, Emily Scofield, Virginia Rose, Adrian Sommerville, Annette Bruce, and commentator Peggy Roberts.

OMEGA SIGMA CHAPTER

OF

DELTA SIGMA THETA SORORITY

PRESENTS

The 1955 Jabberwock

ANYTIME

ANYPLACE

ANYWHERE

BENEFIT SCHOLARSHIP FUND

OAKLAND AUDITORIUM THEATRE

8:15 P.M.

FRIDAY, APRIL 1, 1955

OAKLAND, CALIFORNIA

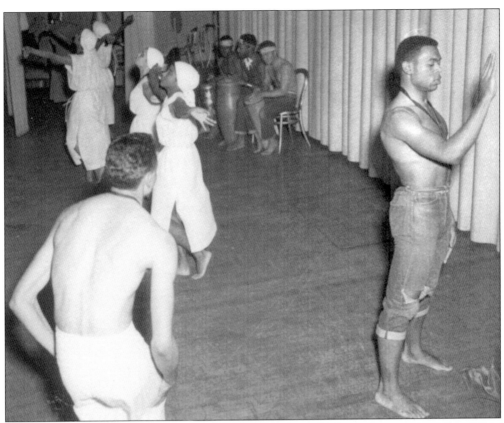

The Omega Sigma chapter of the Delta Theta Sigma sorority sponsored the 1955 Jabberwock to benefit their scholarship fund. Ruth Beckford and her company were guest of honor. The event included a Petro Sacrifice described as a "Haitian Voodoo ceremonial with chicken sacrifice to please the gods, ending with the typical dance of pleasure because the gods have chosen two Hounsi initiates as media." The performance featured Ruth Beckford as Mamaloi, John Lewis as Papaloi, and Marvel Martin as flag bearer. The Hounsi initiates were Betty Carroll, Ann Williams, Antoinette Jackson, Zach Thompson, Clarence Jackson, and Al Jones, and the drummers were Milton Hunt, Carlos De Stefano, and James Jackson.

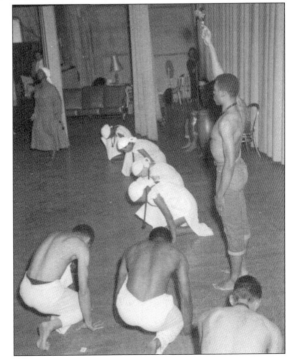

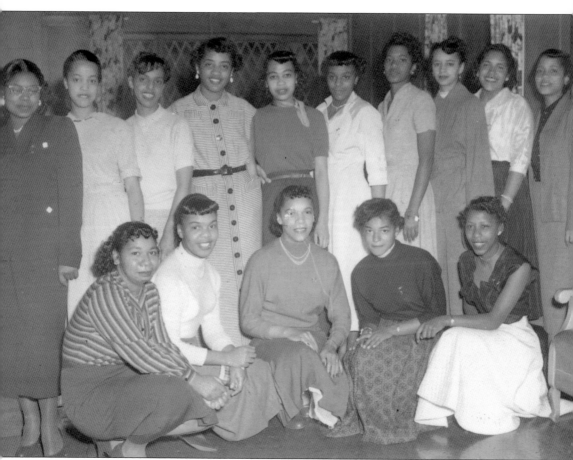

The Kappa chapter of the Delta Sigma Theta sorority is pictured here. From left to right are (first row) Louise Washington, Barbara Bartlow, Juana Taylor, Ruby Brooks, and Jean Harris; (second row) Rowena Anderson, Margaret Smith (treasurer), Santelia Stevens Knight, Gloria Keith (dean of pledges), Dolores Delcombre (recording secretary), Janette Cheltham, Alfreda Lester (president), Delores Morrow (corresponding secretary), Bettie Woolridge, and Gloria Martin.

Ten

MILITARY

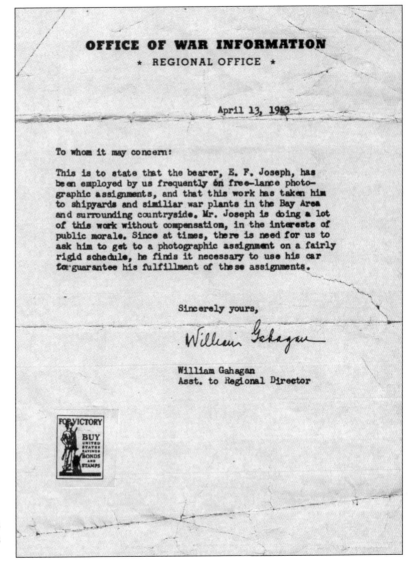

OFFICE OF WAR INFORMATION
★ REGIONAL OFFICE ★

April 13, 1943

To whom it may concern:

This is to state that the bearer, E. F. Joseph, has been employed by us frequently on free-lance photographic assignments, and that this work has taken him to shipyards and similiar war plants in the Bay Area and surrounding countryside. Mr. Joseph is doing a lot of this work without compensation, in the interests of public morale. Since at times, there is need for us to ask him to get to a photographic assignment on a fairly rigid schedule, he finds it necessary to use his car to guarantee his fulfillment of these assignments.

Sincerely yours,

William Gahagan

William Gahagan
Asst. to Regional Director

FOR VICTORY
BUY
UNITED STATES
SAVINGS
BONDS
AND
STAMPS

The Office of War Information gave Joseph a letter authorizing him to enter military shipyards and similar places in the Bay Area.

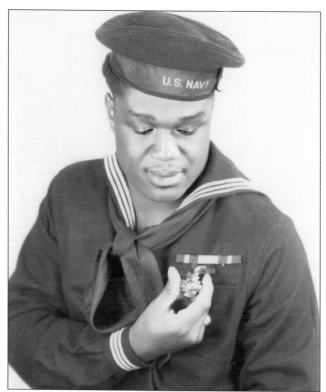

Doris "Dorie" Miller, born on October 12, 1919, was a cook in the US Navy. Noted for his bravery, he endured the attack on Pearl Harbor on December 7, 1941. He earned the Medal of Honor and the Navy Distinguished Service Medal. He was also the first African American to receive the Navy Cross, the highest honor awarded by the US Navy. Miller died on November 24, 1942.

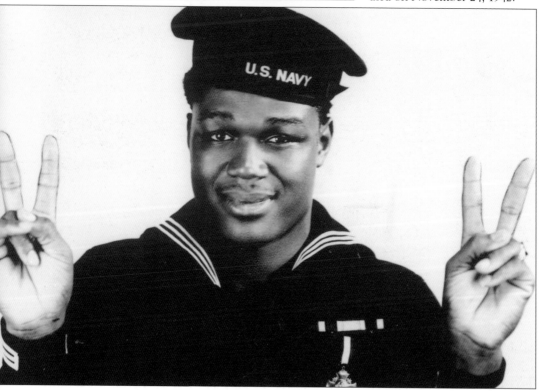

On June 1, 1942, Miller was promoted to mess attendant first class. On June 27, 1942, the *Pittsburgh Courier* called for Miller to be allowed to go on a war bond tour like white heroes.

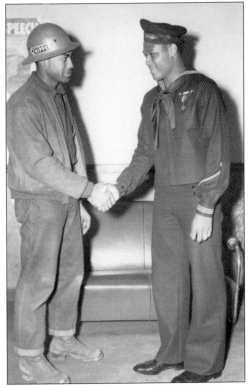

In December and January, the *Pittsburgh Courier* continued to call for Miller to return to the war bond tour. He was seen giving talks in Oakland, California, and greeting the shipyard workers in Richmond, California.

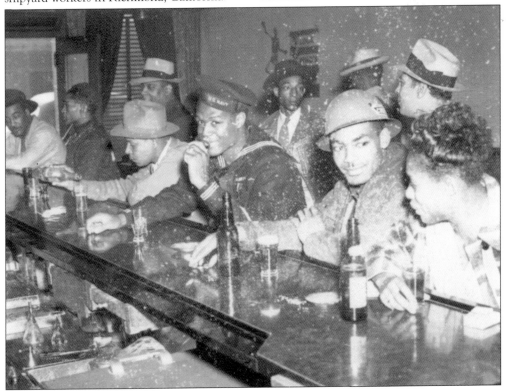

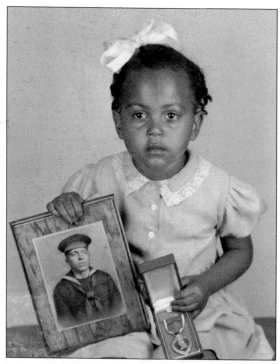

It appears that the father of this unidentified child died in action and received a posthumous medal.

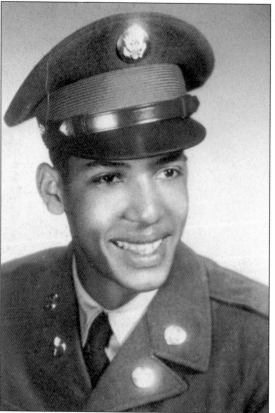

Funeral services were held for Pvt. Albert S. Floyd of Oakland, who was killed at age 18 while fighting with the infantry in Korea. Private Floyd attended St. Elizabeth's and graduated from Oakland Technical High School in May 1950, then entered the Army a few days later. He was survived by his father, Sidney Floyd, and three sisters, Erline, Ruth Marie, and Helen. A rosary was said at the Palmer D. Whitted & Sons Mortuary and St. Patrick's Church.

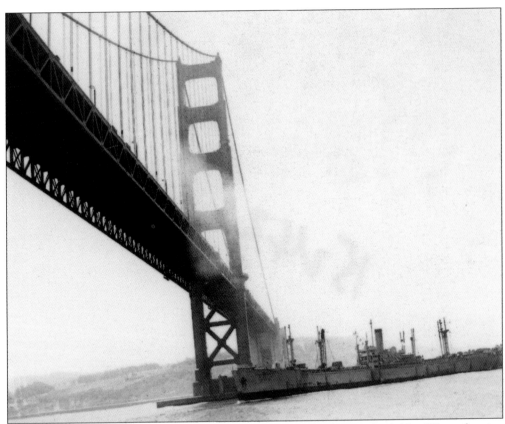

The 9th Infantry, 2nd Division, arrives home via ship after battling in the fields of Korea for nine months. As the vessel passes under the Golden Gate Bridge, troops crowd the deck for a first look at San Francisco. The ship docked at Fort Mason on May 15, 1951.

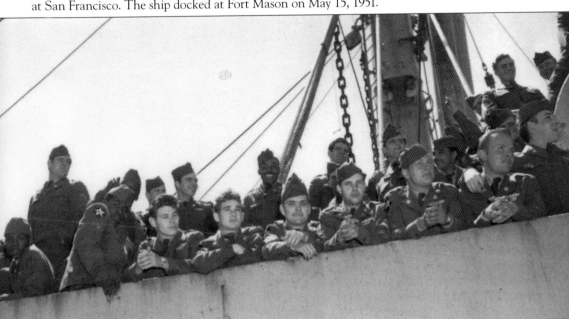

LINCOLN

ERECTED BY PVBLIC SVBSCRIP...
VNDER THE AVSPICES OF THE LINCO...
MONVMENT LEAGVE REPRESENTIN...
THE GRAND ARMY OF THE REPVBLIC
& THE LINCOLN GRAMMAR SCHO...
ASSOCIATION OF SAN FRANCISCO

MCMXXVII

Young men wait in front of San Francisco City Hall to hear Gen. Douglas MacArthur speak on his return home from the Korean War.

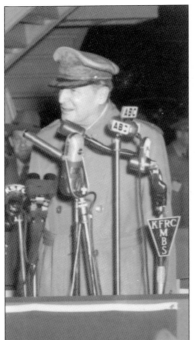

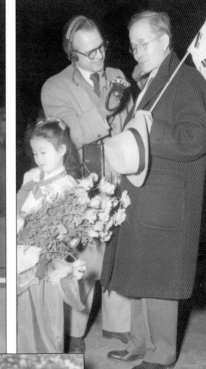

Gen. Douglas MacArthur was welcomed home from Korea with great fanfare.

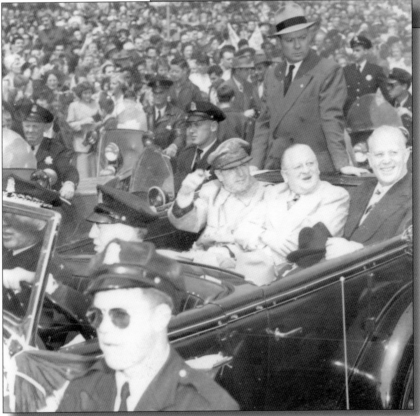

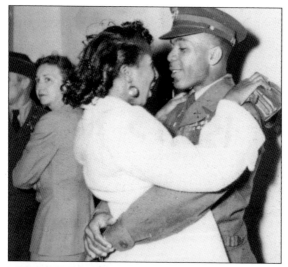

Soldiers are greeted with lots of hugs and kisses at their homecoming from the Korean War, which ended on July 27, 1953. They could hardly wait to see their families and friends, and Korea seems far behind, as seen by the joy on their faces.

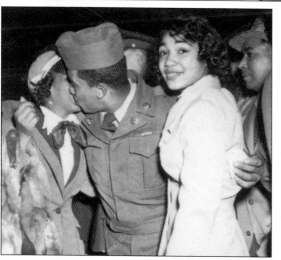

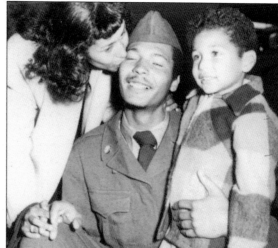

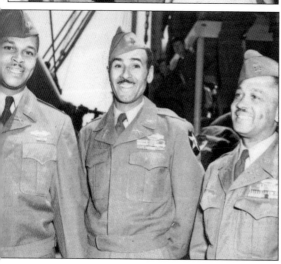

A soldiers' dance was held at the Jewish Center USO of Camp Stoneman, California. At this time, all USO entertainment was segregated.

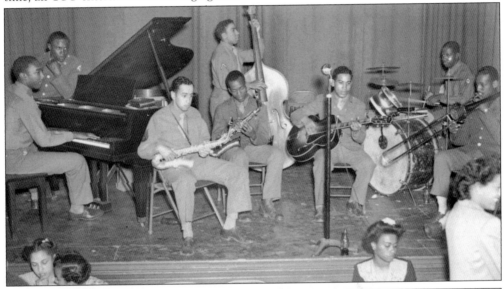

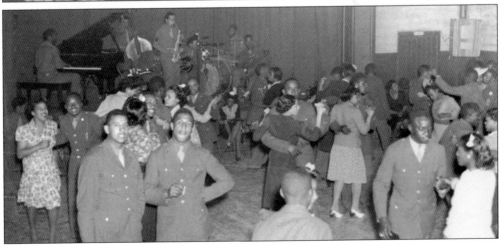

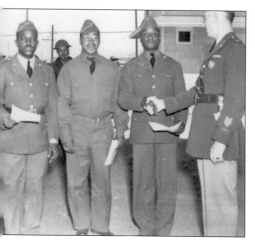
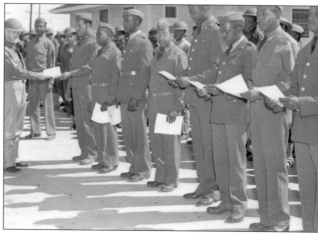

These soldiers are pictured being dismissed from active duty.

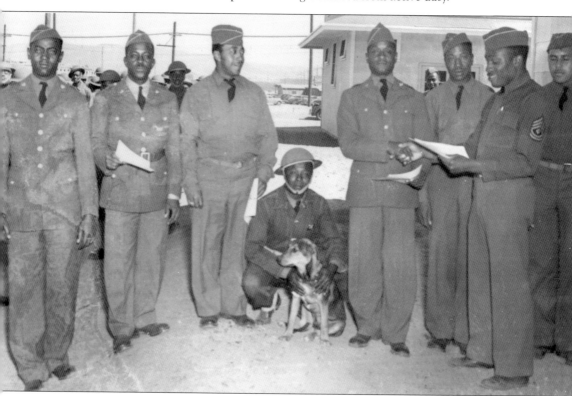

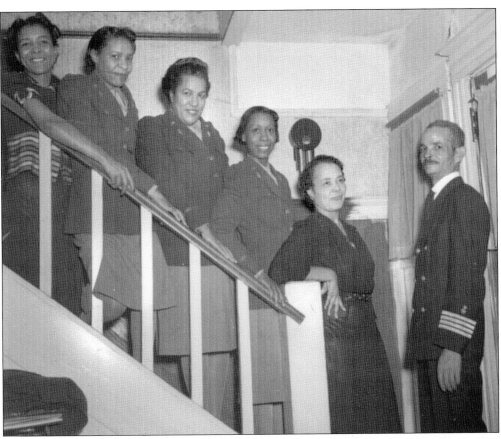

Members of the Women's Army Auxiliary
Corps (WAAC) are pictured here on
February 18, 1943. The Delta Sigma Theta
sorority sponsored this greeting at the home
of Vivian Marsh in Berkeley, California.

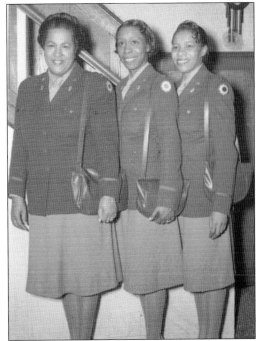

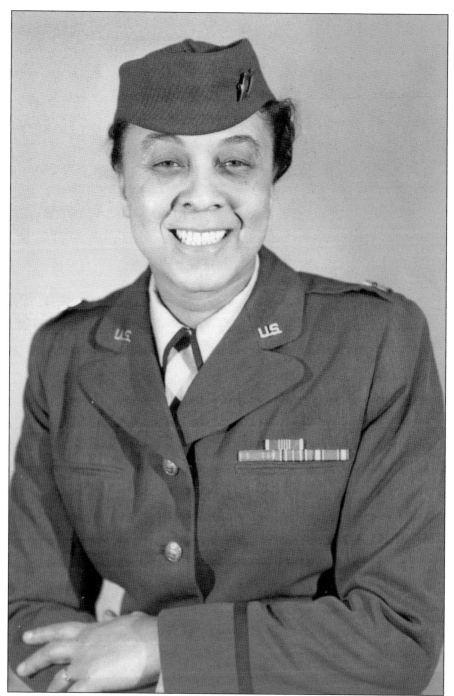

Capt. Oleta Crain enlisted in the Air Force in 1956. When this photograph was taken, she had recently returned to Oakland after spending 10 months in the Alaska personnel office, and she was en route to England to take up new duties. Before enlistment, she was interested in YWCA work and attended the University of Denver, Colorado, where she was working on her master's degree. Crain is a member of the Alpha Theta chapter of the Delta Sigma Theta sorority and one of the first black women in the Air Force.

Eleven

POLITICS

Lionel Wilson was a true Renaissance man. Born on March 14, 1915, he moved to Oakland from New Orleans as a young man. In addition to playing West Coast minor-league baseball, he became a lawyer, a presiding judge in the Superior Court of Oakland, a brother of the Alpha Phi Alpha fraternity, a founder of The Challengers tennis club, and the first black mayor of Oakland, serving three terms from 1977 to 1991. He was also the father of twin sons. The Southwest terminal of the Oakland International Airport is named after him. Wilson died on February 23, 1998.

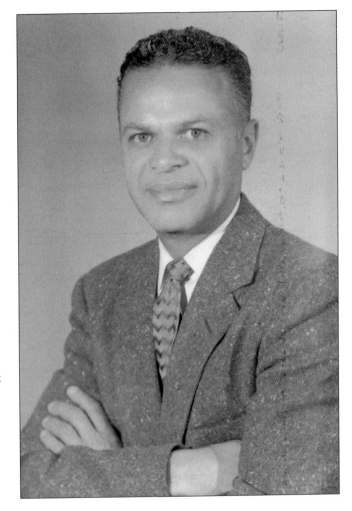

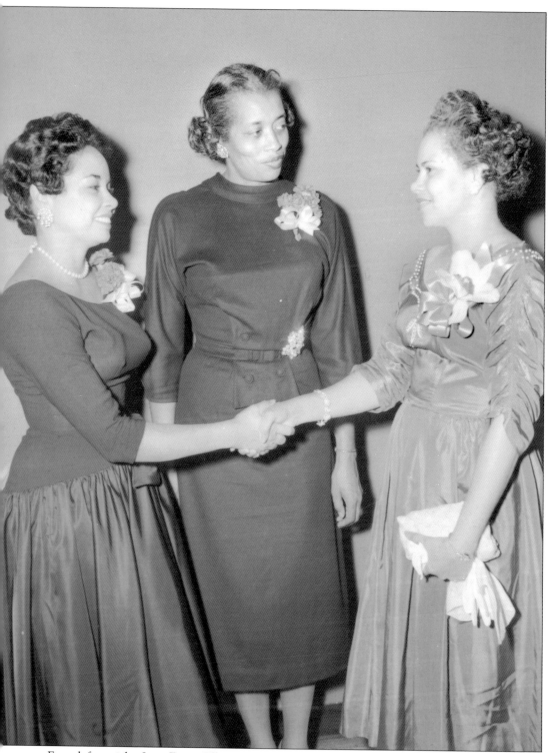

From left to right, Joan Finny, Ella Kinner, and Dorothy Allen are pictured while in attendance at the Democratic Women Political Workshop on August 28, 1959.

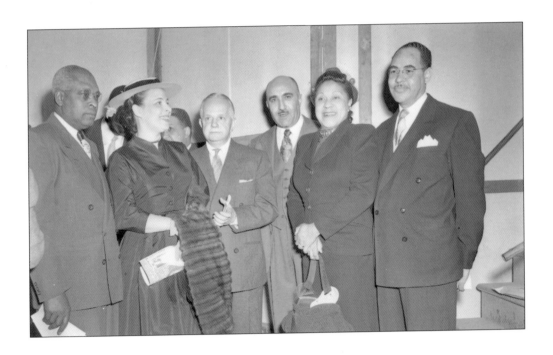

The Northern California Area Conference held memorial services for the late Harry T. Moore. Some 800 people attended the services at the Oakland Civic Auditorium. Walter White, the national executive secretary of the NAACP, was the keynote speaker. He is pictured here at the podium. The invocation was delivered by the Reverend E. Roberts (left), who was also the president of the Santa Clara branch. From left to right are Reverend Roberts. Poppy Cannon White, Walter White, C.L. Dellums, Tarea Hall Pittman of the Northern California Conference, and assemblyman W. Byron Rumford.

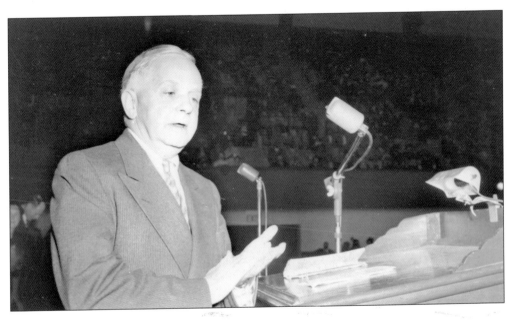

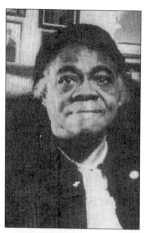

Mary McLeod Bethune (1875–1955) was born in South Carolina and became an educator when she was not accepted as a student in missionary school. She loved education and believed it was the greatest avenue to progress for her people. With $1.54 and five little girls, she started a school in Daytona Beach, Florida. It opened as a school for girls but later welcomed boys. Now, Bethune-Cookman College is one of the most venerable historically black colleges. In 1935, Bethune founded the National Council of Negro Women and served as its first president. She also served as director of the National Youth Administration (NYA) and as adviser to Pres. Franklin Roosevelt. Her friendship with first lady Eleanor Roosevelt was well known. They worked together to advance a range of social, educational, and political causes. The photographs below show Bethune when she spoke at a Democratic rally in Oakland on October 22, 1950.

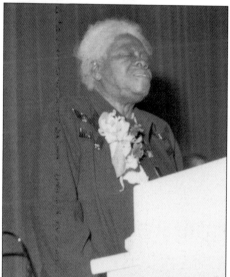

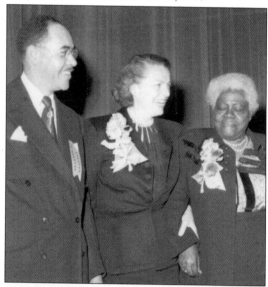

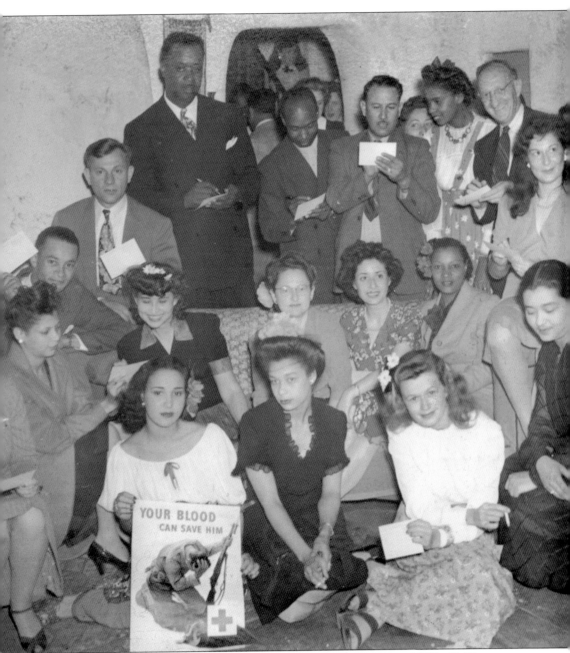

The Communist Party Club is gathered here for a blood drive during World War II. The poster in the foreground reads, "Your Blood Can Save Him," with an image of a soldier. According to one member of the party, "The US government liked us to collect blood, but they didn't like our politics. They never understood what Communists were, what they thought, and what they believed in. They never have taken the time to find out what Communists were up to."

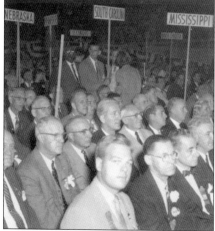

This collection of photographs was taken at the 1956 Republican National Convention in San Francisco.

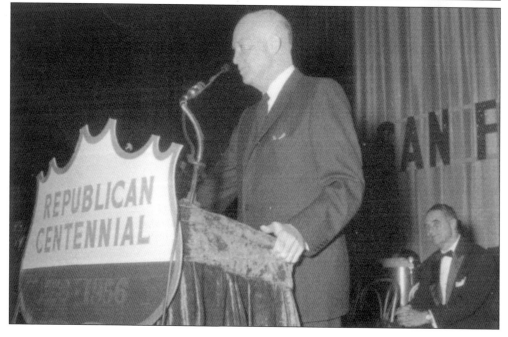

Nationally famous constitutional lawyer Thurgood Marshall (second from left) addressed a crowd of 6,000 people at the public meeting of the NAACP. He presented the people of the Bay Area with his report from conducting a monthlong investigation of the treatment of black soldiers in Japan and Korea. The meeting was held in the main arena of the Oakland Civic Auditorium. Pictured here with Marshall are, from left to right, C.L. Dellums, county branch president; Tarea Hall Pittman, vice president of the NAACP; and Franklin H. Williams, regional director of the NAACP.

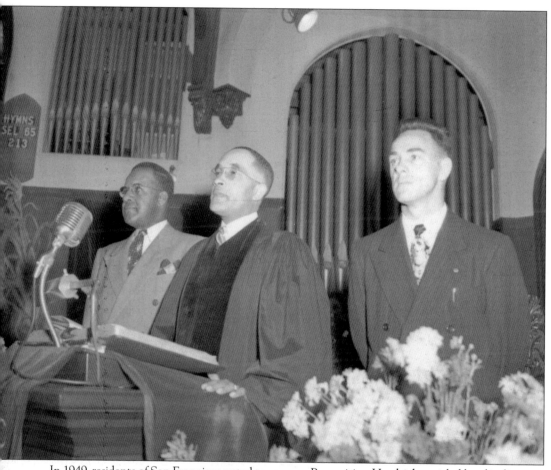

In 1949, residents of San Francisco voted to approve Proposition H, which entitled local policeman to a 40-hour workweek. Patrolman William Glenn (left), who had been a member of the San Francisco Police Department for six and a half years, made an appeal to the members of the Third Baptist Church prior to the vote. Here, he and Sgt. Daniel J. Quinlin (right) of the SFPD have returned to the church to thank the congregation for their support of Prop. H. Pictured with them are the Reverend F.D. Haynes (center), who was the pastor of the church.

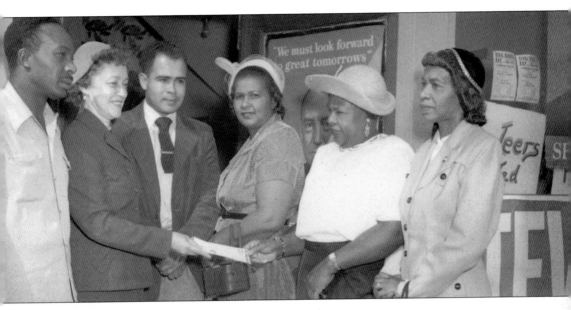

Above, Pauline Wood (second from left), an appointed Democratic county committeewoman, is shown accepting a generous contribution from Lola Godbold (second from right), who was one of the volunteers campaigning with friends to defray expenses toward election of the Democratic candidates. Pictured with them are, from left to right, volunteers Ulysses G. Moore, William Land, Marcelee Cashmere, and Leola Jones. Below, Wood and her volunteers are seen just outside of the 23rd District headquarters of the Stevenson presidential campaign. These photographs were taken in San Francisco and appeared in the *Chicago Defender* on October 24, 1952.

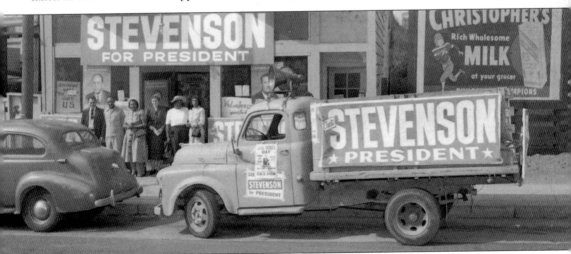

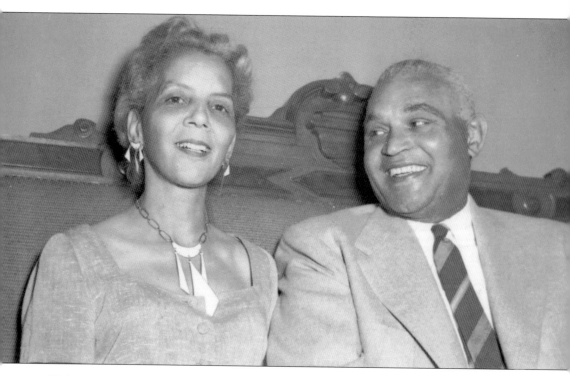

Walter Gordon, pictured here with his wife, Elizabeth, was the chairman of the California Adult Authority, the state paroling agency. He was later appointed governor of the Virgin Islands and served in that role for several years. Below, the Gordons are shown congratulating Dr. Carlton B. Goodlet, editor of the *Sun Reporter* newspaper, when he received a service award.

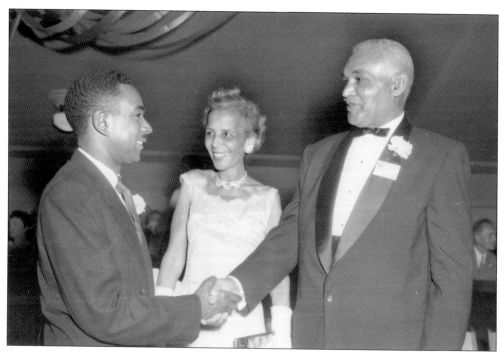

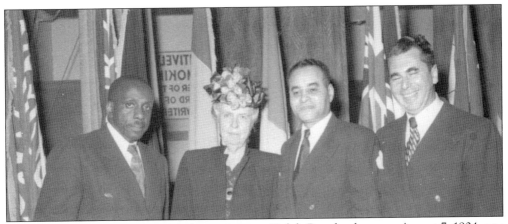

Ralph Bunche, born on August 7, 1904, was the first black man to receive the Nobel Peace Prize, which was awarded to him in 1950 for his mediation between Palestine and Israel. He also received the Medal of Freedom from Pres. John F. Kennedy in 1963, and he was the highest American official in the United Nations. He served as the undersecretary general for political affairs. Bunche died on December 9, 1971.

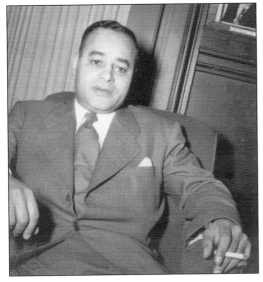

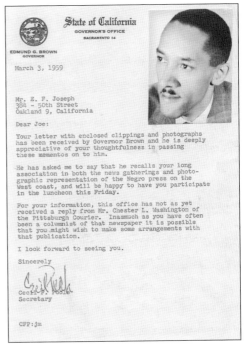

Cecil Poole forwarded a letter from Gov. Edmund G. Brown thanking Joseph for sending him mementos from the black press. Governor Brown also invited Joseph to lunch.

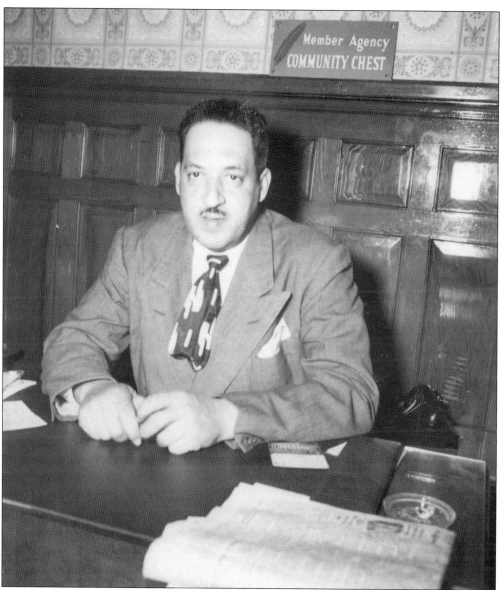

Thurgood Marshall, born on July 2, 1908, was an associated justice of the Supreme Court of the United States, serving from October 1967 to October 1991. He was the first African American justice. Before becoming a judge, Marshall served as the NAACP's chief counsel in the landmark case of *Brown v. Board of Education* in 1954, which declared the segregation of public schools as unconstitutional. Marshall is one of the best-known civil rights figures in the history of America. He was considered the conscience of the court. Marshall died on January 24, 1993.

Twelve

RAILROADS

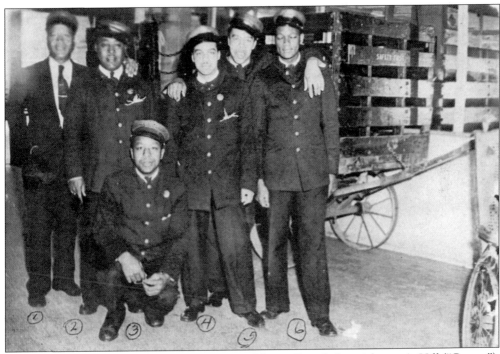

Here is the Brotherhood of Sleeping Car Porters Union. From left to right are A. Hill ("Caruso"),
E. Whitten ("Honey Cut"), A. Hinton ("Know-It-All Hinton"), R. Bryant, I. Allen, and R. Bennett
("Sleeping Jesus").

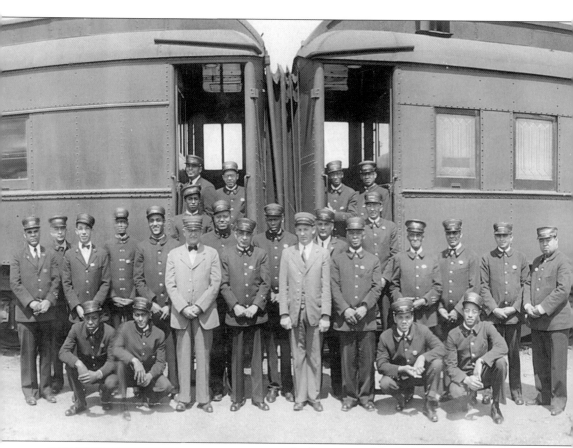

In this image of the Southern Pacific Railroad's redcaps, chief redcap Leon Myers King stands between the two gentlemen in lighter-colored suits. He is also pictured at left in his backyard with friends.

Tom W. Anderson was secretary treasurer of the Dining Car Cooks and Waiters Union Local 456 of the Southern Pacific Railroad in 1949.

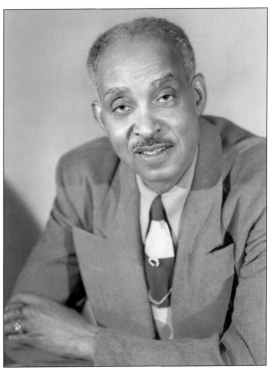

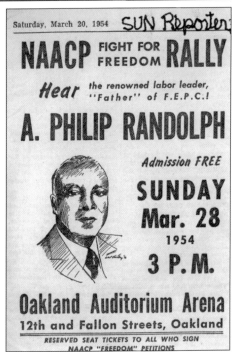

Saturday, March 20, 1954 SUN Reporter

NAACP FIGHT FOR FREEDOM RALLY

Hear the renowned labor leader, "Father" of F.E.P.C.!

A. PHILIP RANDOLPH

Admission FREE

SUNDAY Mar. 28
1954
3 P.M.

Oakland Auditorium Arena
12th and Fallon Streets, Oakland

RESERVED SEAT TICKETS TO ALL WHO SIGN
NAACP "FREEDOM" PETITIONS

A. Phillip Randolph was the president of the Brotherhood of Sleeping Car Porters Union. Other unions did not accept black members. As president, he fought for equal pay to other unionized workers, fringe benefits, and the right to bargain for hours, wages, and other benefits. He worked closely with C.L. Dellums, the West Coast vice president of the union.

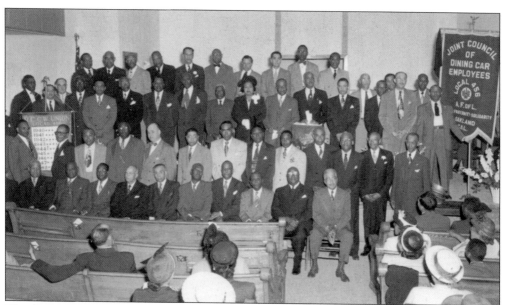

The dining car employees of Local 456 commemorate their lead in impressive rites at the Beth Eden Baptist Church in Oakland. This annual service brought together all of the brothers. Most of them had been with the union for some 26 years. The guest of honor was Henderson Davis, a retired official of the Southern Pacific Railroad. The body voted Davis as honorary member in the Local 456 for his loyal support. Among those participating in the ceremony are Joseph Wade, James J. Dixon, Hattie Shelten (president of the Ladies Auxiliary), Clarence E. Brown, William E. Pollard (general chairman), and T.W. Anderson (secretary treasurer and master of ceremonies).

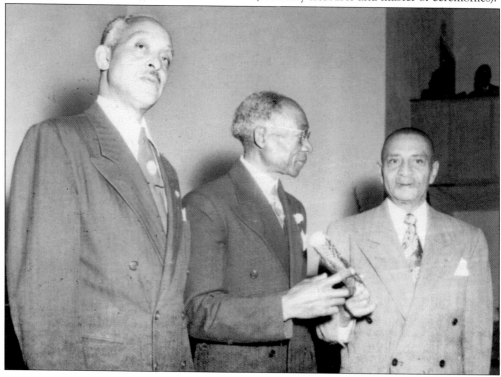

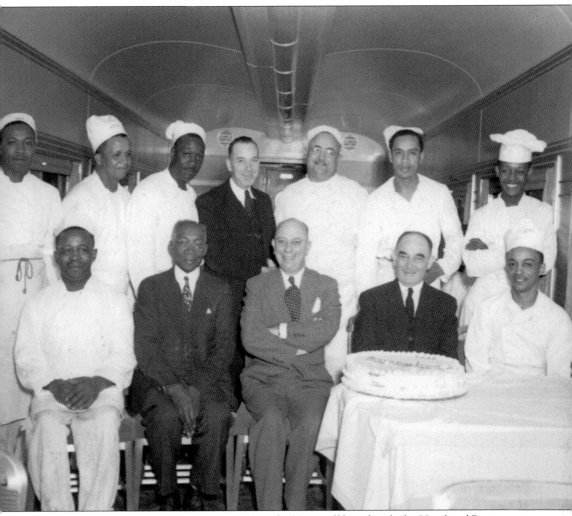

The Dining Car Cooks and Waiters Union Local 456 was affiliated with the Hotel and Restaurant Employees International Union, American Federation of Labor, California State Federation of Labor, and Joint Council of Dining Car Employees. On December 9, 1947, C.O. Sullivan and his supervising force of Henderson Davis, senior instructing chef, and Joseph Seldon, instructing waiter, commended the noon daylight crew for their outstanding service over a 19-month period with no complaints by presenting them with a cake. These dining cars were the largest in the world, with a seating capacity of 100.

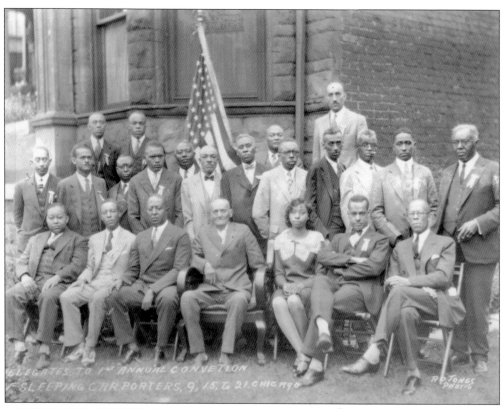

Delegates to 1st Annual Convetion
Sleeping Car Porters, 9, 15 to 21 Chicago
R.D.Jones Photo

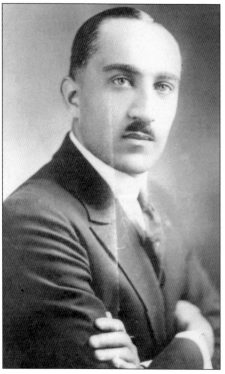

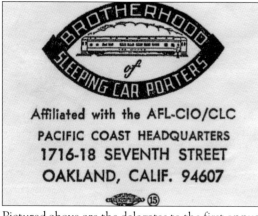

Affiliated with the AFL-CIO/CLC
PACIFIC COAST HEADQUARTERS
1716-18 SEVENTH STREET
OAKLAND, CALIF. 94607

Pictured above are the delegates to the first-annual convention of Sleeping Car Porters held in Chicago. C.L. Dellums, president of the union, is pictured at left on September 5, 1964. The city of Oakland paid tribute to him with a large statue located at the Amtrak depot on Second Street.

Thirteen

SPORTS

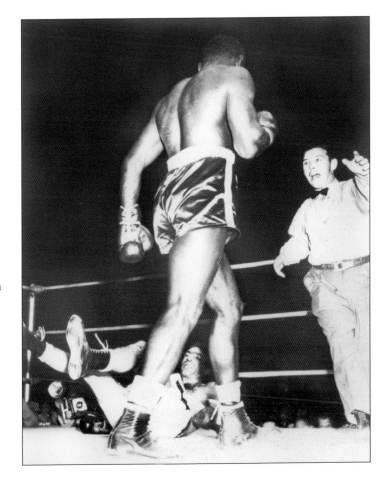

From the first clang of the bell to the final tally, Ezzard Charles outpointed world heavyweight champion Joe Louis in a shocking upset in 1950. Charles was born in Lawrenceville, Georgia, on July 7, 1921. He turned pro in 1940 and fought through three weight classes—light heavyweight, middle heavyweight, and heavyweight—before he retired. Charles died on May 28, 1975.

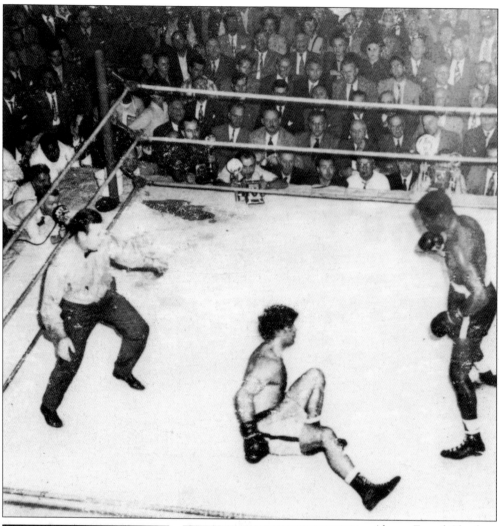

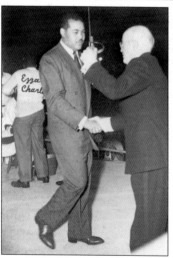

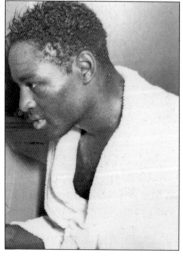

Above, Ezzard Charles throws his typical knockdown punch on October 12, 1949. At far left, Joe Lewis is shown greeting Ezzard Charles's manager.

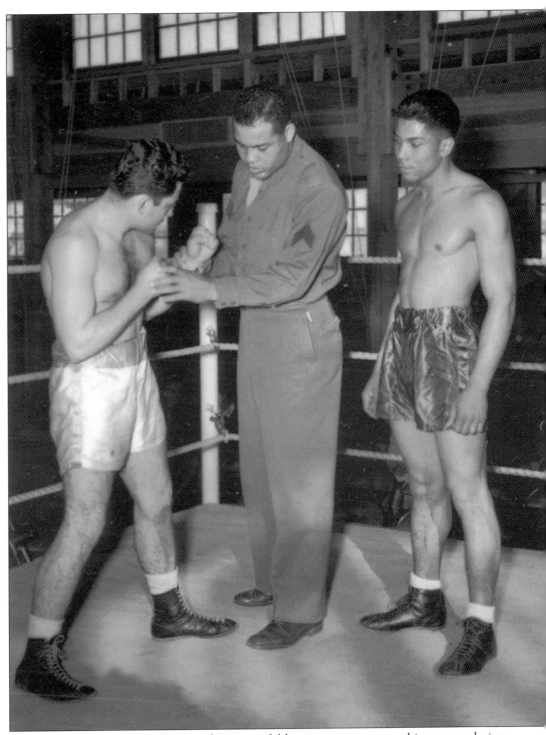

Joe Lewis (center) stepped away from his successful boxing career to serve his country during World War II.

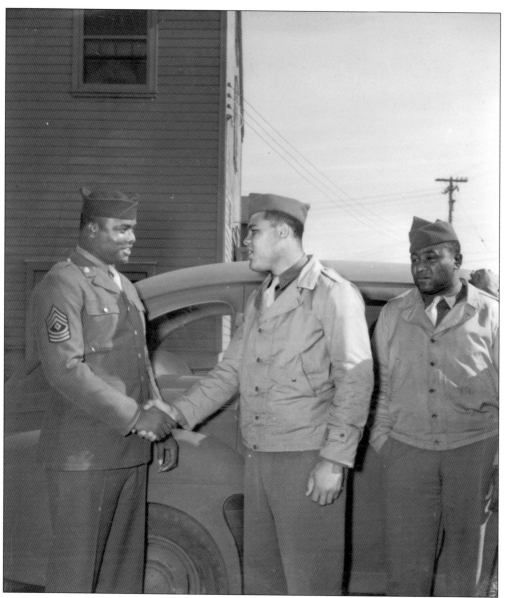

Joe Lewis is pictured here during his time in the Army. These photographs were taken on November 1, 1943. After the heavyweight boxing champion enlisted in the then segregated Army, he donated all his winnings to Uncle Sam while in service during World War II. Despite this incredibly selfless act, he was taxed for the full amount of his fight purses even though he never saw a penny of it.

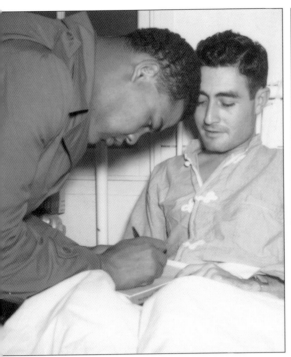

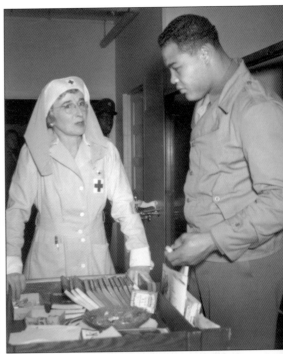

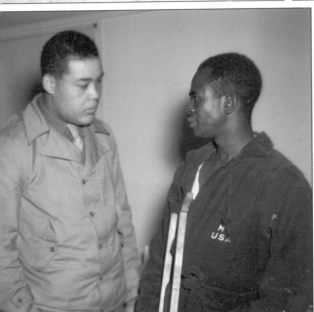

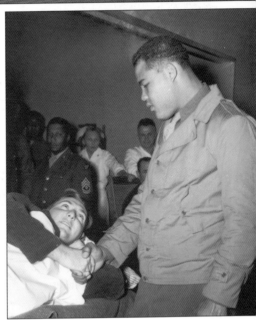

A hospital visit from Joe Louis certainly made the vets feel better.

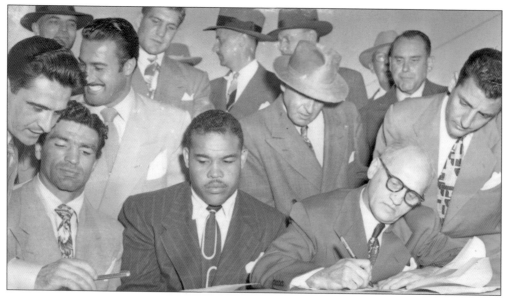

These photographs show Joe Lewis signing for a heavyweight bout on September 14, 1949.

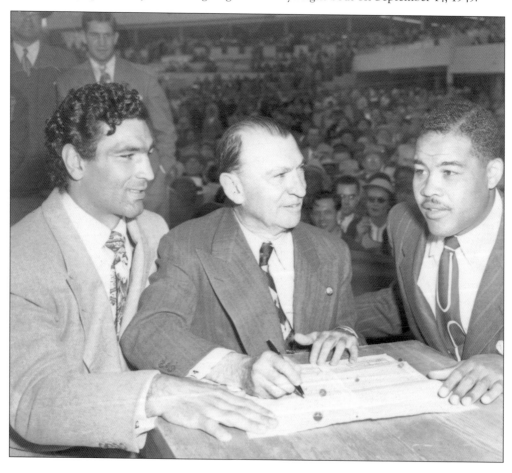

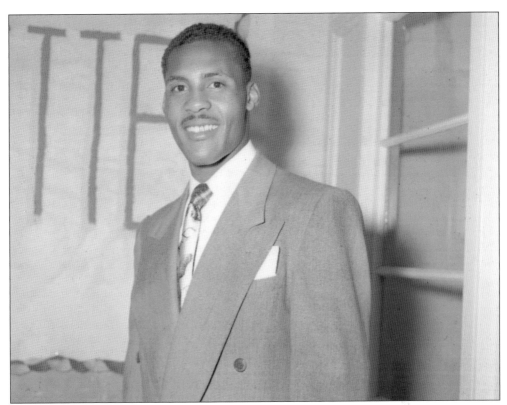

Ollie Matson and the Matsonettes are pictured here on December 1, 1949. Matson was a star football player at the University of San Francisco. He is a local boy who went to elementary school and high school in San Francisco as well. His twin sister married Arthur Thompson, a mortician in Oakland.

On October 30, 1965, Gayle Atwell, daughter of Willie Chambers and W.H. Atwell of Oakland, was voted football queen of Berkeley High School. As a junior, Gayle was one of 21 contestants and the first black girl to reign over the school as football queen. Principal Emory Curtis presented Gayle with a bouquet of American Beauty roses during the football game against Encinal High School of Alameda. Gayle's escort was James Austin, a captain of the football team.

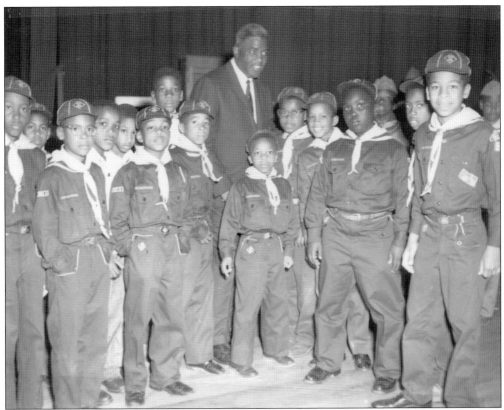

Jackie Robinson, former Brooklyn Dodgers baseball star, spoke at a benefit rally to help raise funds to rebuild the Boys Ranch in Amador City after it was destroyed by fire. California governor Goodwin J. Knight and Oakland mayor Clifford E. Rishell also appeared on the program. A choir of 300 voices from San Francisco and the East Bay churches performed. All proceeds would be used to rebuild the dining hall, recreation center, gymnasium, and school building.

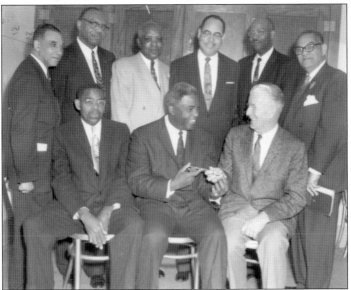

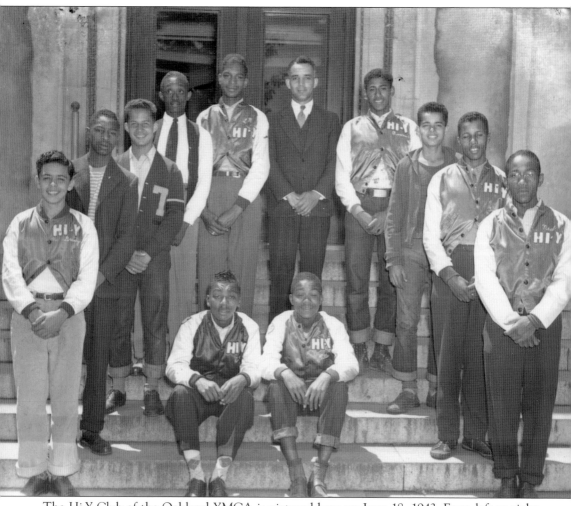

The Hi-Y Club of the Oakland YMCA is pictured here on June 18, 1943. From left to right are (seated) Carlyle Bruins and Wilde Marshall; (standing) William Grundy, Isaac ?, Harold McCormic, Allen Ford, L.M. Johnson, director Josh Rose, Henry Boone, ? McCormic, Tyre Mills, and Lester Neal.

Fourteen

UNIONS

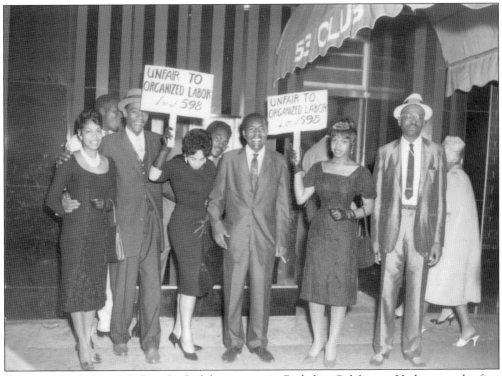

Born on March 31, 1923, Don Barksdale grew up in Berkeley, California. He became the first black professional basketball player in the United States. His nightclub, the 53 Club, was located on Shattuck Avenue in Berkeley and was a popular meeting place for political groups. The Bartenders Union Local 598 held a strategy meeting at the 53 Club on August 8, 1959. Barksdale died on March 8, 1993.

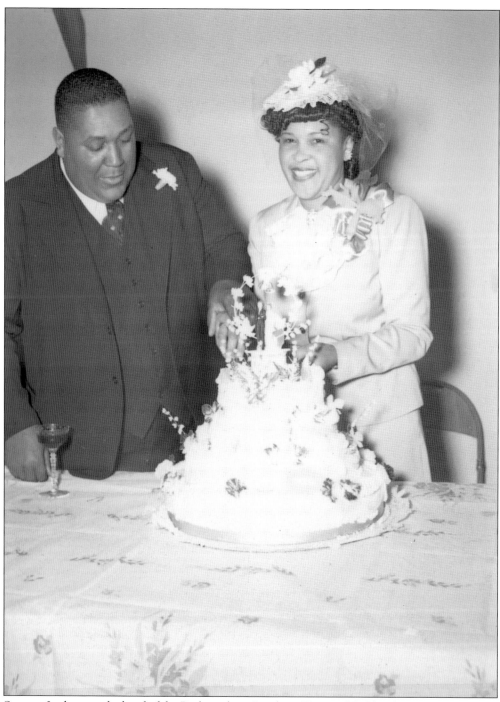

Spencer Jordan was the head of the Boilermakers Auxiliary Union of Oakland A-26. He is pictured here at his wedding with Estelle M. Davis.

These photographs feature members of the Boilermakers Union A-26 baseball team.

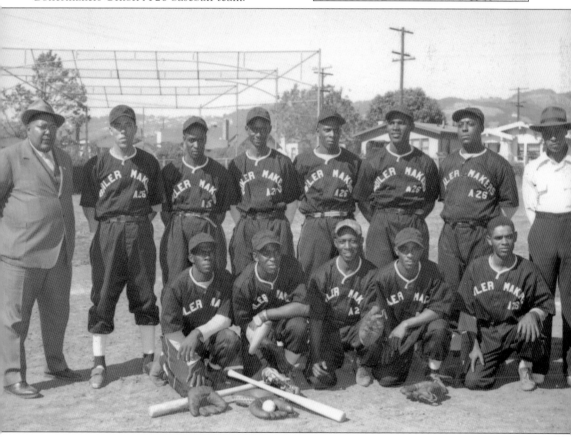

All children were welcome
at the Boilermakers
Union carnival.

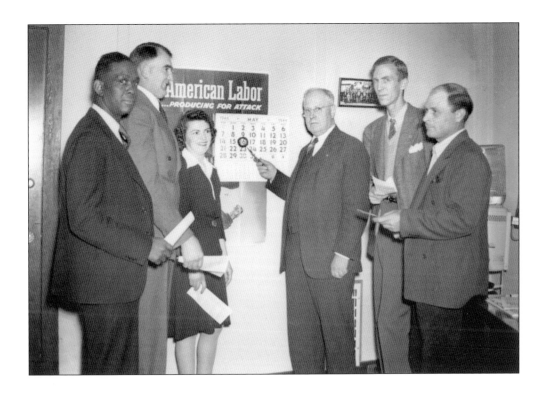

Above, members of the International Longshore and Warehouse Union (ILWU) are shown synchronizing dates on April 10, 1944. Below, the ILWU is registering members to vote. Both of these images were printed in the organization's newspaper, the *Dispatcher*.

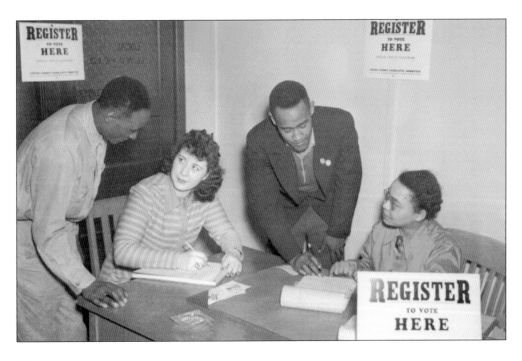

Fifteen

WEDDINGS

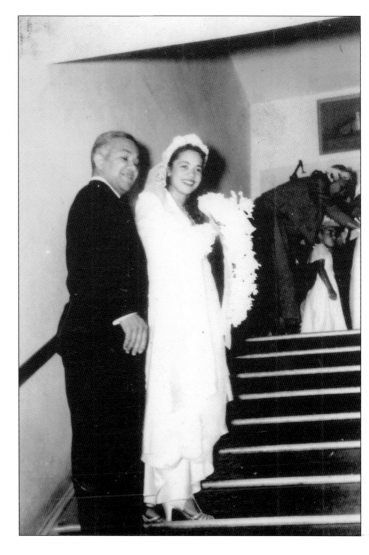

Gail Bomar was married at the Taylor Memorial Church in Oakland in 1949. The bride is pictured here with her father, Theodore, on her wedding day.

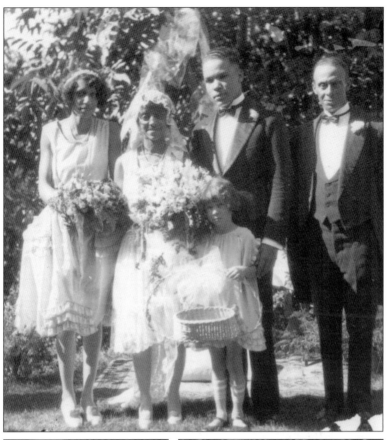

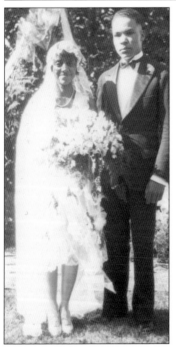

These wedding pictures of Fred Allen and his new wife, Audrey, were taken in June 1927.

Byron Rumford is pictured here with his bride, Elsie Carrington Rumford.

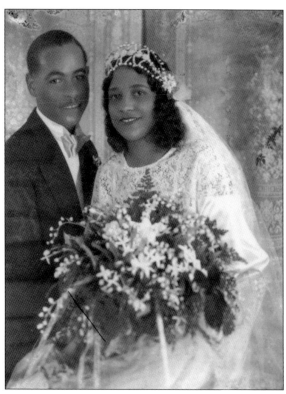

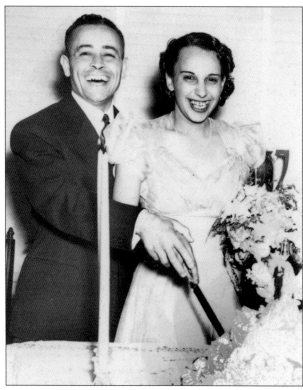

Earl Adams married Zola Morgan on June 15, 1940. Everyone predicted the marriage, as they were inseparable and very happy together.

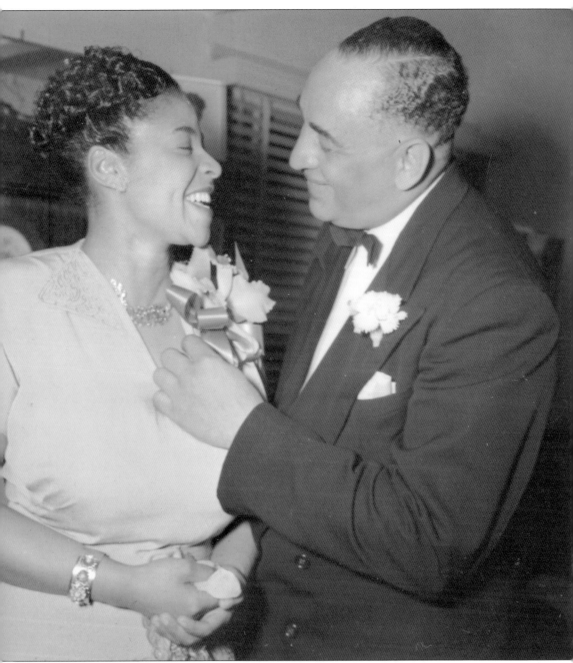

Alice Calbert and the Reverend G. Linwood Fauntleroy were engaged and planning their wedding at the time this photograph was taken. He was a candidate for the California State Senate. Alice was born to Sadie and Riley Calbert in her grandparents' home in Allensworth in the rural San Joaquin Valley on January 15, 1923. She had two brothers. Her father was a college graduate in agriculture and died when she was eight. After his death, the family moved to Alameda. Alice graduated from Alameda High School, then attended nursing school at Highland Hospital in Oakland. She worked for her bachelor of science in public health nursing in New York. When she returned to Oakland, she married Reverend Fauntleroy.

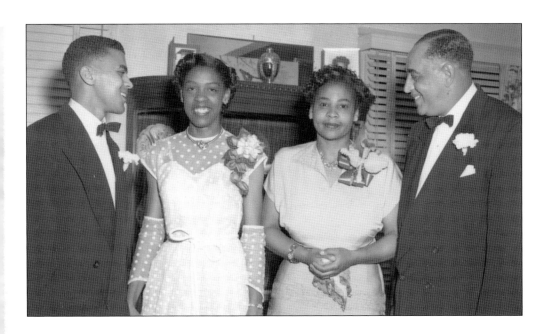

Rev. G. Linwood Fauntleroy and his son Rev. G. Allen Fitch are shown chatting about their upcoming summer nuptials in a double wedding ceremony. The brides are Carrie Mae Johnson (left) and Alice Calbert (right). The reverends officiated at the Greater Cooper AME Zion Church in Oakland. The families of both couples are pictured below.

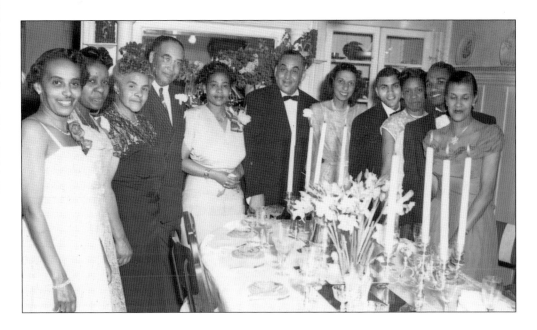

INDEX

9th Infantry, 2nd Division, 77

13 Charms Club, 64

53 Club, 113

500 Bridge Club, 56

Acty, Ruth, 66

Adams, Earl, 121

Allen, Audrey, 120

Allen, Dorothy, 86

Allen, Fred, 120

Allen, I., 97

Anderson, Marion, 21

Anderson, Tom W., 99, 100

Anderson, Rowena, 72

Atwell, Gayle, 110

Bailey, Jasper, 57

Baker, Josephine, 16

Barksdale, Don, 113

Bartenders Union Local 598, 113

Bartlow, Barbara, 72

Bay Area Workers Council, 47

Beavers, Louise, 27

Beckford, Ruth, 24, 25, 71, 127

Bell, G.M., 59

Bell, Reverend, 33

Bennett, R., 97

Bethany Baptist Church, 43

Bethel, Freda, 54

Bethune, Mary McLeod, 88

Boilermakers Auxiliary Union of Oakland A-26, 114–117

Bomar, Gail, 11, 119

Bomar, Theodore, 119

Boone, Henry, 112

Bridges, Evelyn, 53

Brooks, Ruby, 72

Brotherhood of Sleeping Car Porters Union, 97, 99, 102

Brown, Lillian, 47

Brown, Myrtle, 53

Brown, Rod, 51

Bruce, Annette, Dr., 64, 65, 69

Bruins, Carlyle, 112

Bryant, R., 97

Bunche, Ralph, 95

Calbert, Alice, 122, 123

Calbert, Riley, 122

Calbert, Sadie, 122

California Hotel, 34, 35

California Morticians Association, 37

Capwell, H.C., 69

Carroll, Kay Frances, 53

Carver National Insurance Company, 33

Charles, Ezzard, 103, 104

Cheltham, Janette, 72

Colman, Lyta Marie, 53

Committee on Crime and Correction, 49

Communist Party Club, 89

Cooper, Joan California, 17

Crain, Capt. Oleta, 84

Dantlay, Clemmie, 64

Davis, Henderson, 100, 101

Delcombre, Dolores, 72

Dellums, C.L., 87, 91, 99, 102

Dining Car Employees Local 456, 99–101

Divine, Lester, 49

Dixon, James J., 100

Dunham, Katherine, 18, 19

East Bay Organizers Employment Committee, 45

Evans, Margueritte, 54

Fauntleroy, Rev. G. Linwood, 122, 123

Finny, Joan, 86

Fitch, Rev. G. Allen, 123

Fitzgerald, Ella Jane, 26

Fleming family, 59

Floyd, Pvt. Albert S., 76

Francis, Victoria, 55

Glenn, William, 92

Golden Gate Bridge, 77

Gordon, Elizabeth, 62, 94

Gordon, Walter, 28, 49, 62, 94

Greater St. Paul Missionary Baptist Church, 43

Grundy, William, 112

Hampton, Lionel, 20

Harris, Jean, 72

Haynes, Rev. F.D., 92

Henderson, Elberta, 53, 69

Hill, A., 97

Hinton, A., 97

Hoover, Ella, 60

Hoover, Merrill, 60

Hoover, Sylvia Buck, 60

Hoover, William, 60

Horne, Lena, 15

Howser, Fred, 44

Hulett, Angelica, 53

Hulett, Rose Mary, 53

Humphrey, Josephine, 66

Ink Spots, 26

International Longshore and Warehouse Union, 118

Jackson, Bernice, 53

Jackson, Ida, 68

Jackson, Mahalia, 22, 23

Jewish Center USO, 81

Joseph, Alyce, 10

Johnson, Carrie Mae, 123

Johnson, L.M., 112

Johnson, Sargent, 28

Jordan, Spencer, 114

Joseph, E.F., 2, 9, 11–14

Keith, Gloria, 68, 72

Kilpatrick, Vernon, 49

King, Leon Myer, 98

Kinner, Ella, 86

Knight, Santelia Stevens, 72

Lartigue, Lucy, 7, 10

Lester, Alfreda, 72

Lewis, Joe, 104–108

Lewis, Margaret, 52

Lewis, Lina, 54

Links Inc., 52–54

Lloyd, Frishby Ann, 53

MacArthur, Gen. Douglas, 79

McCormic, Harold, 112

Marsh, Vivian, 83

Marshall, Thurgood, 91, 96

Marshall, Wilde, 112

Matson, Ollie, 109
Miller, Doris, 74, 75
Mills, Tyre, 112
Moore, Harry T., 87
Moore, Rev. A.A., 42
Moore, Ulysses G., 93
Morgan, Zola, 121
Morrow, Delores, 72
National Council of Negro Women, 88
Neal, Lester, 112
Neeley, Beverly, 54
Office of War Information, 73
Paramount Theatre, 46
Penn, Mildred, 53
Phyllis Wheatley Club, 55
Pittman, Tarea Hall, 87, 91
Pittsburgh Courier, 48
Pollard, Geneva, 64
Pollard, William E., 100
Poole, Cecil, 95
Proposition H, 92
Quinlin, Sgt. Daniel J., 92
Randolph, A. Phillip, 99
Redskins Boycott Bus, 48
Reid, Careth B., 7, 126
Republican National Convention, 90
Richardson, Raye and Julian, 32
Rickmond, Andrea, 53
Rickmond, Dr. Arthur E., 51, 56
Rickmond, Milou, 53
Rickmond, Lorraine, 54, 56
Rickmond, Michelle, 54
Rishell, Clifford E., 49, 111
Roberts, Peggy, 69
Roberts, Rev. E., 87
Robinson, Jackie, 111
Robeson, Paul, 46
Roosevelt, Pres. Franklin, 88
Roosevelt, Eleanor, 88
Rose, Virginia, 53, 61, 69
Rumford, Byron, 44, 49, 58, 87, 121

Rumford, Elsie Carrington, 58, 121
Rumford Pharmacy, 36
Rumford, Randolf, 58
Rose, Joshua, 61, 112
Safeway Stores, 50
Sanders, Robert, 11
Scofield, Emily, 69
Scott, Sylvia Turner, 60
Seldon, Joseph, 101
Shelten, Hattie, 100
Slim Jenkins, 30, 31
Smith, Margaret, 72
Solid Rock Baptist Church, 41
Sommerville, Adrian, 69
Southern Pacific Railroad Red Caps, 98
Stevenson campaign, 93
Sullivan, C.O., 101
Taylor, Juana, 72
Taylor Memorial Church, 11, 41, 119
Third Baptist Church, 39, 92
Thompson, Arthur, 109
Thompson, Ray, 46
Thurman, Rev. Howard, 40
Tilghman, Charles H., 38
Tilghman, Hettie, 55
Toller, Burl, 68
Toller, Melvia, 68
Wade, Joseph, 100
Ware, John, 33
Washington, Louise, 72
Watson, Rev. H.W., 44
White, Walter, 87
White, Poppy Cannon, 87
Whitten, E. 97
Williams, Franklin H., 16, 91
Williams, Gaynell, 53
Wilson, Lionel, 55, 85
Wilson, Valda, 64
Women's Army Auxiliary Corps, 83
Woolridge, Bettie, 72
Worth, Beatrice, 56
Young, Jean, 53

CARETH REID

Careth "Diddy" Reid, born June 15, 1931, is well known for her more than four decades of work as director of community service programs in the San Francisco Bay Area. She has a master's degree in social science and a lifetime teaching credential. She purchased all of E.F. Joseph's historical information from his widow in 1980 and has stored his negatives for nearly 40 years. She went to his birthplace in St. Lucia to see if she could locate his family. She found his 93-year-old sister, who shared additional information regarding their family.

Reid holds numerous awards presented by various organizations. She worked as an instructor in the Secondary Education Department of San Francisco State University. Before teaching at State, she worked as the admissions director of the Presbyterian Medical Center in San Francisco. She was also the national coordinator of youth programs for the National Conference of Artists. She served on Mayor Willie Brown's Study Group Coordinating Children's Services and on the mayor's Head State Task Force. She was the recipient of the San Francisco State University Alumna of the Year Award in 1990, and she was inducted into the university's Hall of Fame in 1992.

Ruth Beckford

Ruth Beckford, born December 7, 1925, has been a dancer, teacher, choreographer, actor, published author, and playwright. She also volunteered as a motivational speaker in women's maximum-security prisons in California. Beckford is a native of Oakland and still resides in the area. She started studying all forms of dance at three years old. She joined the Katherine Dunham Dance Company in 1943 and toured briefly in Canada. She left the company, choosing her education over performing, and attended the University of California, Berkeley. In 1947, she became the founder of the first modern dance department of the Oakland Recreation Department, the first of its kind in the country. She opened her African Haitian Dance Studio featuring Dunham Technique in Oakland in 1952.

Beckford was the recipient of the Oakland Technical High School's Centennial Celebration as an Outstanding Alumni in 2015. She is featured in a mural in downtown Oakland honoring local artists. Her dancing figure is three stories tall. After her retirement from dance, she enjoyed participating in a range of other arts. She is also listed in the Library of Congress in Washington, DC. The collection of her artifacts is preserved in the Bancroft Library of the University of California, Berkeley.

Working Together

We visit each other often by phone: "Good morning, Ms. Diddy Reid." "Good morning, Ms. Ruth Beckford." Then we are off and running, solving the world's problems.

Diddy and I have been friends for more than 50 years. She's a Berkeley native, and I'm an Oakland native. We became closer friends when her daughter Gail became a member of my Oakland Recreation Teen Modern Dance Honor Society. Later, they were both students at my African Haitian Dance Studio.

As we became senior citizens, our health became a challenge. Mine progressed as my joints cried out after 47 years of dance stress. Hers was a sudden stroke on her 80th birthday, leaving a very active Diddy in a wheelchair. But we did not give up. The discipline of physical therapy and positive attitudes have kept us physically limited but still active. Diddy's determination has led her left hand to successfully take over the duties of her paralyzed right hand, and she rides her stationary bike three times a week for 20 miles each time. I am so proud of her.

She no longer has the single white braid that hung down her back, below her waist. Now, she sports a very attractive short, gray, curly Afro. We may not look the same, but we are "feeling fine."

—Ruth Beckford

DISCOVER THOUSANDS OF LOCAL HISTORY BOOKS
FEATURING MILLIONS OF VINTAGE IMAGES

Arcadia Publishing, the leading local history publisher in the United States, is committed to making history accessible and meaningful through publishing books that celebrate and preserve the heritage of America's people and places.

Find more books like this at
www.arcadiapublishing.com

Search for your hometown history, your old stomping grounds, and even your favorite sports team.

Consistent with our mission to preserve history on a local level, this book was printed in South Carolina on American-made paper and manufactured entirely in the United States. Products carrying the accredited Forest Stewardship Council (FSC) label are printed on 100 percent FSC-certified paper.

MADE IN THE USA